Survey map of Grave-Talbot track by T. W. Preston, 1924. *(National Archives, Dunedin)*

MILFORD SOUND

An Illustrated History of the Sound, the Track and the Road

A fine study of Donald Sutherland in 1911 by Norman Deck. *(George R. Chance collection)*

MILFORD SOUND

An Illustrated History of the Sound, the Track and the Road

John Hall-Jones

Dedication

*To our children
and grandchildren*

Published by Craig Printing Co. Ltd, P.O. Box 99, Invercargill, New Zealand

© 2000 John Hall-Jones

This book is copyright. Except for the purposes of fair reviewing, no part of this publication, including the photographs, maps and drawings, may be reproduced or transmitted in any form or by any means, electronic or mechanical, including photocopying, recording or by any information storage and retrieval system, without permission in writing from the publisher.

ISBN 0-908629-54-0

Printed by Craig Printing Co. Ltd, PO Box 99, Invercargill, New Zealand.
Email: print@craigprint.co.nz Website: www.craigprint.co.nz
2000 – 147356

Contents

Introduction and Acknowledgements ... 7

Chapter

1 MILFORD HAVEN ... 9
2 THE HERMIT OF MILFORD SOUND ... 23
3 THE MACKINNON PASS ... 32
4 QUINTIN MACKINNON ... 42
5 PIONEER TREKKERS .. 49
6 THE MILFORD TRACK DEVELOPS .. 54
7 GLADE HOUSE .. 60
8 THE FINEST WALK IN THE WORLD ... 69
9 TE ANAU AND THE LAKE STEAMERS ... 80
10 THE GRAVE-TALBOT TRACK ... 88
11 THE MILFORD ROAD BEGINS .. 102
12 CHRISTIE SURVEYS THE TUNNEL .. 109
13 THE ROAD PROCEEDS TO THE TUNNEL ... 113
14 THE ROAD FROM MILFORD ... 120
15 THE HOMER TUNNEL ... 130

Epilogue .. 139

Appendices

A Sutherland's visitors book ... 142
B Historical guide to the Milford Road ... 143

Bibliography .. 145

Index ... 146

Also by John Hall-Jones:

Early Fiordland, 1968
Mr Surveyor Thomson, 1971
The Invercargill Rotary Club, 1974, 1999
Bluff Harbour, 1976
Fiordland Explored, 1976
The Invercargill Club, 1979
Fiordland Place Names, 1979
The South Explored, 1979
An Early Surveyor in Singapore, 1980
New Zealand's Majestic Wilderness, 1981
Goldfields of the South, 1982
Pioneers of Te Anau, 1983
The Thomson Paintings of the Straits Settlements, 1983
Glimpses into Life in Malayan Lands, 1984
Doubtfull Harbour, 1984
The Catlins Guidebook, 1985
Jonathan White's New Zealand, 1986
Martins Bay, 1987
Supplement to Doubtfull Harbour, 1988
Footsteps in the Wilderness, 1989
Discover the South, 1991
John Turnbull Thomson: First Surveyor-General, 1992
Stewart Island Explored, 1994
The Horsburgh Lighthouse, 1995
Discover Fiordland, 1997

Introduction and Acknowledgements

Proclaimed as "the eighth wonder of the world" majestic Milford Sound is one of the great scenic icons of New Zealand. Here are the loftiest sea-cliffs in the world, the strikingly shaped spire of Mitre Peak rising straight from the sound, the great glaciated dome of Pembroke Peak, the cascading column of the stately Bowen Falls. Small wonder that "far-famed Milford Sound" becomes the ultimate aim of many visitors to New Zealand whether they go there by the Milford Road, a spectacular scenic drive in itself, the Milford Track "the finest walk in the world", by plane landing on its mountain-crowded airstrip, or by cruise boat entering the narrow confines of this great glacier-carved fiord.

Surprisingly an overall history of this much visited sound, its road and its track has never been written. Here then are the first impressions of the early Europeans to visit this "most remarkable harbour in New Zealand". The accounts of the sealer John Boultbee, the *Acheron* surveyors and the geologists Sir James Hector and Robert Paulin. The two Welsh captains, Grono and Stokes, who named many of the features after their homeland, Milford Haven in Wales. New light is shed on the explorations of Donald Sutherland, the hermit of Milford Sound, and whether or not he climbed the Mackinnon Pass before Quintin Mackinnon. Here too is the story of the famous Milford Track and the carving of the Milford Road and Homer Tunnel through the snowy mountains to the sound.

Here are the deeds of brave William Quill who climbed the Sutherland Falls three times; Jim Dennistoun who made the first ascent of Mitre Peak in a pair of gym shoes!; surveyor John Christie who descended the awful cliffs of the Homer Saddle on a wire rope; the student track-cutters who opened up the Grave-Talbot track before the road went through. The delightful stories of William McHutcheson including his lively descriptions of their guide "Mac" Mackinnon and "Old Brod" who delivered the party to the start of the Milford Track in his steamboat, "full bustin'-power in the toobes".

In researching this book I am particularly indebted to:

- Dr Peter Jennings for sending me his father's (Dr David Jennings') unique collection of photographs and letters of the students who cut the Grave-Talbot track;
- Hector Gough for providing me with a first hand lucid account of the construction of the road from Milford to the Homer Tunnel illustrated with his own excellent photographs;
- My uncle Jack Christie for his vivid account of the survey of the Homer Tunnel illustrated with his own photographs;
- Jean Wilson, widow of road engineer Raymond Wilson for providing me with a windfall of historic photographs of the construction of the road, all meticulously labelled by Raymond;
- Robin Jackson for lending me her family's collection of material on road engineer Harold ("Smithy") Smith;
- Ex-Milford Track guide Ray Willett for lending me a number of historic photographs of the track and Stuart Kerr for providing early photographs of the huts from his father's (Colin Kerr's) collection;
- Keown Shirley for his fascinating illustrated account of Pompalona hut in 1932;
- Kathy and Terry Gilligan and Carley Burnby for assisting me with a large collection of historic photographs that they have been cataloguing;
- Rachel Edgerton of DOC Te Anau for her invaluable help in unearthing old files and photographs;
- Dave Edge, pilot to South Port, for his extensive knowledge of cruise ships to visit Milford Sound over the years.

In researching the old hut sites at Anita Bay I am indebted to Fiordland Travel Ltd for putting Russell Beck and myself ashore for our survey of these sites in 1999.

In pinpointing the historic sites on the Milford Road and Track I was assisted greatly by Ken Bradley of DOC Te Anau, and Murray Gunn of the Hollyford Camp and Museum. Also all the hut wardens and managers on the track, particularly Liz and Les Galloway of Glade House who went to some considerable trouble to provide me with photographs and the story of the fire there in 1929.

The Hocken Library and the Alexander Turnbull Library were, as always, most helpful in assisting me in my researches, also the National Archives in both Wellington and Dunedin, the Otago Settlers Museum and the Invercargill Public Library.

Finally I am most grateful to my brother Gerry and my wife Pamela for reading through the manuscript of the book and offering helpful suggestions. In doing so Gerry pointed out to me that if the Darran Pass had been discovered earlier it would have led to a much easier route for the Grave-Talbot track and perhaps the Milford Road.

HMS Acheron entering Milford Sound in 1851, her "masts dwindling into nothing beneath the towering cliffs". The Maori canoe off Anita Bay is added. Watercolour by Captain F. J. Evans. *(Alexander Turnbull Library)*

CHAPTER 1

Milford Haven

Milford Sound is the most remarkable harbour yet visited by the Acheron in New Zealand.
George Hansard, 1851

On 7 March 1851 Captain John Lort Stokes sailed the wooden paddle-steamer *HMS Acheron* into Milford Sound on the last leg of his marathon survey of the West Coast Sounds. "Milford Sound" wrote George Hansard in his journal, "is the most remarkable harbour yet visited by the *Acheron* in New Zealand. [Here] the *Acheron's* masts dwindled into nothing beneath the towering cliffs. As the ship came abreast of the first cataract [Stirling Falls] the brilliant sunbeams refracted in the spray, which rose in clouds from its base, showed all the rainbow's prismatic colours." It was a "most lovely day, warm and sunlit" and the *Acheron* "anchored abreast a second waterfall, 200 feet high, [the Bowen Falls] which seemed to burst from a large reservoir with an incessant roar. [A roar] which was heard with additional solemnity during the stillness of the night."

A magnificent painting by Captain Frederick (later Sir Frederick) Evans, the *Acheron's* master, shows how the barque-rigged steamer was anchored in Freshwater Basin (now the cruise boats' anchorage) close to the Bowen Falls. Interestingly he depicts a party of Maori on the mudflats at the head of the sound (in front of the present hotel), although there is no reference to meeting any Maori in Milford Sound in either Hansard's journal or the ship's log. In the centre of the painting is the great glacier dome of the "perpetually snow-capped" Pembroke Peak. To the left in the painting is "the remarkable shaped Mitre, rising abruptly to 5,560 feet [from the sea]", which Commander George (later Sir George) Richards describes as "perhaps the most striking feature of the whole sound". Opposite Mitre Peak are the Stirling Falls, the "first waterfall" that the *Acheron* passed on her way into the sound. Leading back from the Stirling Falls is the "dome-shaped" Lion which, because of its "peculiar colour", Richards describes as "resembling a huge mountain of metal".

"The head of the sound", continues Richards, "terminates in two basins, Freshwater Basin and Deepwater Basin, separated by a low tongue of wooded land fronted by a tidal boulder bank". The *Acheron* chart shows the old course of the Cleddau River entering Freshwater Basin, hence the name. After

Sketch of the Stirling Falls by F. J. Evans, 1851. *(National Maritime Museum)*

HMS *Acheron* anchored in Freshwater Basin, 1851. Painted from the head of the sound by F. J. Evans. The Maori figures are added. *(Alexander Turnbull Library)*

Vice-Admiral Sir George Richards, Hydrographer of the Royal Navy (1864-74), who, as Commander of the *Acheron*, graphically described Milford Sound in 1851. *(A. Day)*

Captain Sir Frederick Evans, Hydrographer of the Royal Navy (1874-84), who in 1851 made several sketches and paintings of Milford Sound. *(A. Day)*

anchoring overnight in Freshwater Basin the *Acheron* moved over to Deepwater Basin (now the fishing boats' anchorage) where there was "a greater depth of water" and moored "in a river" (the Arthur River where the Milford track now ends).

"Dr Lyall [the ship's surgeon] and party set out [for] the snow covered mountain in sight [Mt Pembroke]. They brought back ducks, kakapo and one kiwi", records Hansard. "They fancied they caught sight of a mysterious bird known only to [George] Stevens [the local pilot], no one else has seen it." A bird which Stevens describes as of "intense and magnificent plumage, All colours!" As Hansard's journal contains a very complete list of birds, including all those likely to be confused with the takahe (notornis) there is little doubt that he is giving us one of the very earliest reports of this very rare species.

Comparing Milford Sound with all the other sounds they had surveyed Commander Richards considered Milford, although shorter than most, "far surpasses them all" for its "remarkable features and magnificent scenery. Its narrow entrance, with its stupendous cliffs which rise perpendicularly as a wall from the water's edge to a height of several thousand feet, invest Milford Sound with a character of solemnity and grandeur which description can barely realise."

The *Acheron* made to depart from Milford Sound on 13 March but was detained for a week in Anita Bay at the entrance by adverse weather. "By anchoring half a cable off shore and hauling close in with hawsers fast to the trees the *Acheron* found considerable shelter. Much of the greenstone lying about the beach [of Anita Bay]", writes Hansard "was an inferior type called Takawai which for the most part is little esteemed by the Maori [for tools]. Of [this] fine rich green and semi-transparent kind, most of their personal ornaments were formed."

Eventually they got away from Anita Bay and as they sailed up the coast the surveyor-artist W. J. W. Hamilton executed a fine sketch of the "Land to

the Northward of Milford Haven" showing the huge bulk of Pembroke Peak (labelled Milford Peak by Hamilton) on the right, Mt Tutoko (labelled New Peak), the highest peak in Fiordland, on the left, and the Matterhorn-like peak of Mt Grave in between.

Hamilton's use of the term "Milford Haven" on his sketch is interesting. The same term was also used earlier on the coast by Hansard before they entered Milford Sound. It was Stokes who changed the name to Milford Sound on his map, but the name Milford Fiord would have been a better choice, it being a glacier carved fiord.

The Welsh Connection

Although the *Acheron* surveyors knew that some early Welsh sealer had bestowed the original name "Milford Haven" to Milford Sound they were unaware as to who he was. "The Welshman who first penetrated into this deep inlet", writes Hansard, "seems to have retained but an imperfect recollection of the celebrated haven of his native land after which he thought proper to name it".

The sealer John Boultbee uses the name "Milford Haven" in his journal in 1826 but the name was bestowed before then. An old sealing map by Edward Meurant uses the name Milford Haven and the answer to Stokes' query lay on this chart. Meurant gives the name "Gronow's" for Doubtful Sound, but unfortunately misspells it by adding a "w". Puzzled by this name Stokes gave the names Groznoz Bay and Mt Groznoz in Doubtful Sound, thinking that it must be one of the group of Spanish place-names in that sound. We now know that the famous sealer Captain John Grono had a sealing base in Doubtful Sound and that Meurant's spelling should have been "Grono's".

Captain Grono came from Newport, a few kilometres north of Milford Haven in Pembrokeshire. He was sealing on the Fiordland coast as early as 1809 and was responsible for naming a number of important features including

Sketch of the "Land to the Northward of Milford Haven" by surveyor W. J. W. Hamilton showing the huge bulk of "Milford Peak" (Mt Pembroke). *(A. Day)*

An early map of the West Coast Sounds by the sealer Edward Meurant showing the names "Milford Haven" for Milford Sound and "Gronow's" for Doubtful Sound. *(E. Shortland)*

The famous sealer Captain John Grono who named Milford Haven after his homeland in Wales. *(K. Brown)*

Below: Captain John Lort Stokes of *HMS Acheron* who also lived near Milford Haven, Wales, and gave a number of its place-names to Milford Sound, New Zealand. *(National Library of Australia)*

Thompson Sound after the owner of his sealing ship the *Governor Bligh*; Bligh Sound after this vessel; Nancy Sound after another of his ships and Milford Haven after his homeland. When D'Urville was planning to visit Fiordland in 1823 it was Grono, who knew the coastline so well, who supplied D'Urville's cartographer Jules de Blosseville with detailed sailing directions for entering Milford Sound. Although D'Urville's expedition never got there Grono's directions were still published.

"In front of the entrance to Milford Harbour is a rock which has the appearance of a ship under sail [Brig Rock]. As it stands about five miles from the harbour it is an excellent guide. The channel to the south of this is the best, the northern passage being dangerous. A mile past the southern headland [St Anne's Point] is a little island [Post Office Rock, off Fox Point]. Keeping close to this island a southern direction should be taken to anchor in the most suitable position [Anita Bay]. [Here] no inhabitants are to be found; the forest spars are of excellent quality and in abundance; and enormous mountain ranges covered with perpetual snows can be seen in the interior".

By an extraordinary coincidence Captain Stokes also came from Pembrokeshire, Wales, and lived even closer to Milford Haven than John Grono. As a sailor whose home was at Haverfordwest, seven killometres from Milford Haven, Stokes would be thoroughly familiar with the places around the harbour and was in an unique position to bestow their names to features around Milford Sound in New Zealand. No doubt he would take considerable pleasure in doing so. The names that appear on Stokes' chart of Milford Sound that are derived from Milford Haven include Pembroke Peak, Benton Peak, Llawrenny Peaks, Cleddau River, Dale Point, St Anns Point and Williamston Point.

Diagram showing the origin of Milford Sound place-names from Milford Haven, Pembrokeshire. *(J. Hall-Jones)*

The great fortress of Pembroke Castle, Milford Haven, Pembrokeshire. *(J. Hall-Jones)*

being another name for Cleddau, Milford Haven is really the "mouth of the Cleddau".

At the mouth of the Cleddau River, where it enters the Haven, is Benton Castle which Stokes was obviously thinking of when he named Benton Peak. On the opposite bank of the river is the charming medieval village of Lawrenny which Stokes was relating to when he named the Llawrenny Peaks (spelling it with an extra "l"). On a point close by is the tiny hamlet of Willliamston, which explains Stokes' name Williamston Point in Milford Sound. Stokes' home at Haverfordwest was only seven kilometres up the Cleddau River from its mouth and doubtless he would be thoroughly familiar with all these places as he boated down the river to the harbour.

On the south side of the Haven I visited the great fortress of Pembroke Castle and felt how appropriate it was that Stokes gave this name to the massive Pembroke Peak.

In 1979 while researching *Fiordland Place-names* I visited Milford Haven in Pembrokeshire curious to track down the origins of these names that appear on Stokes' chart of Milford Sound. Arriving at the great harbour I was intrigued to learn that Nelson had once described Milford Haven as "one of the best harbours in the world". Proceeding to the head of Milford Haven I found that a Cleddau River enters the head of the harbour there in the same way as it does in New Zealand. I was further intrigued to learn that the old Welsh name for Milford Haven is Aber-gleddye. "Aber" meaning the "mouth of" and Gleddye

The great glaciated dome of Mt Pembroke, Milford Sound, New Zealand. *(J. Hall-Jones)*

The lighthouse tower erected at St Ann(e)s Point at the southern entrance to Milford Sound in 1937. Dale Point opposite. *(Alexander Turnbull Library)*

Times I learned that Stokes was born at Scotchwell House in 1812 and died there in 1885 at the age of 73 having attained the rank of a full admiral and served the town and Pembrokeshire as a magistrate. His two officers, Commander Richards and Captain Evans also did well, each in turn becoming the Hydrographer of the British Navy and both receiving knighthoods.

I continued on to Newport where Captain John Grono was born in 1763. In 1798 Grono came out to Australia where he acquired a farm and shipbuilding yard on the Hawkesbury River. From there he became famous for his sealing expeditions and place naming on the Fiordland coast.

Two cutters anchored in Anita Bay in 1890. The dinghy is ashore at the western end of the bay. The islet off Fox Point is Post Office Rock. *(Alexander Turnbull Library)*

At the entrance to Milford Haven I took the coastal walk around Dale Point and St Anns Head, two more names that appear on Stokes' chart. But being more of a point than a headland Stokes called it St Anns Point, spelling it correctly without an "e". It was only later that it was changed to St Annes Point on New Zealand charts. It was also intriguing to find that St Anns Head, Pembrokeshire, had a lighthouse because, by complete coincidence, a lighthouse was later erected on St Annes Point at the entrance to Milford Sound.

Following up the Cleddau River from Milford Haven I came to Haverfordwest where Stokes' house, Scotchwell, a fine old manor, is still standing. From his obituary in the

Anita Bay

To the Maori the main attraction to Milford Sound (Piopiotahi) was its rich source of clear, translucent greenstone (takiwai) at Anita Bay. Although takiwai (bowenite) is softer than the other type of greenstone (nephrite) and no use for making tools or weapons it was nevertheless much sought after for ornaments, particularly long pendants. Expeditions by canoe from both the South and North Island tribes voyaged to Anita Bay seeking the precious stone. Emphasising the importance of Anita Bay to the early tribes the Maori scholar James Cowan informs us that the Maori name for Milford Sound, Piopiotahi the native thrush, applied originally to Anita Bay only. Likewise, of the Maori artefacts that have been recovered from the whole of Milford Sound, almost all came from Anita Bay and only a few from the head of the sound and Lake Ada, where the Maori hunted for eels.

The attributes of bowenite, its clarity and beauty, were recognised early by Maori and many fine works of art have been made from takiwai. The translation of the Maori takiwai (tangawai in the North Island dialect) is tear drop and there are some colourful legends as to its origin including the petrification of the tears of some mythical characters weeping for their departed loved ones. The water-worn pebbles of the translucent pea-green "tear drops" can still be picked up from the beach at Anita Bay, mainly at its eastern end.

The earliest European inhabitants of Anita Bay were the sealers who had a "crazy hut" there. The sealer John Boultbee and his mates hauled their boat out on to the beach and slept the night in the hut. "Milford Haven", writes Boultbee, using the sealers' name for the sound, "is a wild romantic looking place, abounding in high mountains and intermediate deep vallies. The woods are abundantly supplied with game, [such] as woodhens [wekas], green birds [kakapo], emus [the larger species of kiwi] etc. On the left side of this place [he was coming from the north] is a deep and narrow passage [the Narrows] between two tiers of mountains which we called the flue, through which the wind blows at times with great violence."

Although John Boultbee makes no mention of the greenstone at Anita Bay he does give us a dramatic first ever description of the Narrows of Milford Sound. The appearance of his journal which surfaced only recently also clarifies what has been described in the past by Herries Beattie as the "massacre of Anita Bay". Beattie was told the story by an elderly Maori "informant", but the details are so bizarre that it cannot be believed. It is now thought that Beattie's informant was telling of the sacking of the Maori village at Jacksons Bay, which took place after two of Boultbee's fellow sealers were murdered by Maori at Arnott Point to the north. A sort of utu (Maori revenge) in reverse. Beattie was not strong on his localising of places and Boultbee gives us a firsthand account of these murders further north.

The MacDonald brothers' stone house at the eastern end of Anita Bay, 1932. Roy MacDonald (left), Guy Murrell leaning against house. *(Rod MacDonald)*

Remains of the MacDonald brothers' stone house in 1999. *(J. Hall-Jones)*

MILFORD SOUND

Hugh McKenzie's abandoned corrugated iron hut at the western end of Anita Bay, 1958. *(L. Thompson)*

Hugh McKenzie, who had a vegetable garden at Anita Bay during the 1930s. *(M. A. Gunn)*

The first European to recognise the value of the bowenite at Anita Bay was Captain William Anglem of Stewart Island. During the early 1840s Captain Anglem collected some of the bowenite off the beach and successfully exported it to Sydney. In 1842 in a more ambitious scheme he made plans to sell the stone direct to the Chinese market. Unfortunately Anglem was grieviously injured in a blasting operation while collecting the stone (either here or at Barn Bay to the north), but Captain Henry Fox of the *Anita* arrived to transport the cargo to China, only to have it rejected because it wasn't the usual hard jade type of stone that they were used to. Nevertheless the name of Fox's vessel was given to the bay and his own to the point, Fox Point, at the western end of the bay. The tiny islet of Fox Point was called Post Office Rock because Captain Anglem left and picked up his mail from there while working the greenstone at the other end of the beach.

In 1863 the geologist James Hector landed at Anita Bay and found "plenty of rounded greenstone pebbles" among the shingle of the beach but could not discover the source whence they were derived". In 1889 another geologist, Robert Paulin, found "a quarry of [the bowenite] on the face of a hill just above the bay which appears to have been worked some time or other". This prompted a miner, William Bertram of Dunedin, to prospect the bay in 1906 and after driving a shaft through an old slip at the back of the bay he announced that he had rediscovered the mother lode. He formed the Milford Sound Greenstone Co. to extract the stone but the venture failed and in 1908 the company went into liquidation.

In 1932 the MacDonald brothers, Roy and David, assisted by Guy Murrell, built a stone house towards the greenstone (eastern) end of the bay. The brothers used the house as a base to work their gold claim at the mouth of the John O'Groats River on the coast to the north which they commuted to by open boat. Later they built a wooden hut a little to the east of their stone house. The original stone house has since partially disintegrated but most of the stacked stone walls are still standing and have recently been renovated. On our survey of the wooden hut site in 1999 Russell Beck and I discovered that the MacDonalds also had a steam pipe there for bending the boards of the boat that they were building.

At the other end of the bay, towards Post Office Rock, Hugh McKenzie of Martins Bay had a house and garden where during the 1930s he grew potatoes and vegetables for Mr and Mrs Charles Long of the Milford Hotel. Hugh McKenzie dug up several Maori artefacts from his garden including whole and broken adzes which he gave to the Longs.

Sir James Hector's Visit

In 1863 the Otago provincial geologist Dr (later Sir James) Hector visited

MILFORD HAVEN

Sketch of the head of Milford Sound, 1863, by John Buchanan showing the old course of the Cleddau River (in foreground) and the mouth of the Arthur River (centre).
(Buchanan papers)

The geologist James Hector who explored Milford Sound in 1863.
(Hocken Library)

Milford Sound in the schooner *Matilda Hayes*. Also on board was the botanist-artist John Buchanan who leaves us a superb water-colour painting of the sound and an interesting sketch of the head of the sound showing the old course of the Cleddau River entering Freshwater Basin and the Arthur River entering Deepwater Basin. In between is the *Acheron's* "low tongue of wooded land".

As the *Matilda Hayes* approached the entrance at dawn "the sharp serrated crests" of the summits appeared to form a "dark wall rising close to the water's edge", wrote Hector. Then "as the sun rose it slowly lit up the mountains in their true grandeur". As they proceeded up the sound it became "contracted to a width of half a mile" (the Narrows) where its "sides rise perpendicularly from the water's edge to 2,000 feet. The scenery is quite equal to the finest that can be enjoyed by the most difficult journeys into the Alps of the interior", except in this case the access is "made easy by the incursion of the sea into the alpine solitudes".

"Two hours sail brought us into a fresh water basin where we anchored and a large tent was put on shore." They lay "within a few hundred feet of a cascade", the Bowen Falls, which remained un-named until the visit of the Governor Sir George Bowen in 1871 in HMS *Clio* commanded by Captain Stirling, after whom the Stirling Falls were named.

"The volume of the [Bowen Falls]" continues Hector, "is very considerable

Sketch from the head of Milford Sound by Sir James Hector, 1863. Note his name "Metal Peak" for the Lion. *(Alexander Turnbull Library)*

Sketch of the Bowen Falls by F. J. Evans in 1851 showing the "grassy hummocks", but no sign of any graves. *(National Maritime Museum)*

especially after heavy rains. The dashing of the wind and spray from the falling water has prevented the growth of scrub on a small plot" at the foot of the falls. Then in a fascinating explanation as to why the *Acheron* called this area Cemetery Point, Hector tells us how the "plot is covered with grassy hummocks, not unlike graves, which doubtless suggested the name Cemetery". As if to confirm this with visual evidence Captain Evans of the *Acheron* executed a fine sketch of the falls with the "grassy hummocks" beneath without any sign whatsoever of a grave or a tombstone. Over the years a legend has evolved that the point was named Cemetery because the *Acheron* found the graves of "three or four American whalers" there. But there is no suggestion of this in either the *Acheron's* log or journal. By coincidence, however, probably because the area was already named Cemetery Point, the Milford trackhand William Rathbun was buried there when he died in 1894. More recently a memorial stone was erected at Cemetery Point when six Japanese tourists and their pilot died in an horrific mid-air collision with another plane in 1989.

On 10 August 1863 Hector set out to explore the Cleddau Valley but found it "rough and hard work as the channel is blocked by large boulders" so that they had to cross and recross the river very frequently. "Four miles up the river, on a tributary from the south-east [the Gulliver River] I found the recent camping place of a party of diggers who had laboriously cut a track through the thicket along the side of the river." Returning to the sound Hector examined Deepwater Basin where he found another camping place with a message carved on a tree, "Nugget, 5th June, 1863, R. D. K.". It was "probably [carved] by the same prospectors that had been up the Cleddau", comments Hector. At Harrison Cove he found "another of their camping places of a later date".

While sailing about the sound the *Matilda Hayes* spotted "large shoals of porpoise [bottle-nose dolphin, ten to twelve feet in length which Buchanan depicts in his painting]. They swim with great speed, raising their back fin out of the water every few minutes and sometimes leaping several feet clear of the surface. I shot one", reports Hector in this first record of dolphins in Milford Sound, which fortunately survive there in good numbers. They also saw "several seals about the mouth of the sound", which were "easily shot but impossible to secure" because the water was "so deep close to the shore".

On 17 August Hector returned to his exploration of the Cleddau Valley, this time taking with him three companions, a tent and provisions enough for several days. After a rough scramble up the icy waters of the Cleddau riverbed the stream "ended quite abruptly" at the head of the valley. In this first ever description of the vicinity of the future Homer Tunnel he found himself "surrounded by precipitous mountains 5,000 feet in height, with detached snowy peaks several thousand feet higher. I could see that there was no hope of finding a saddle at the head of this valley", he reported.

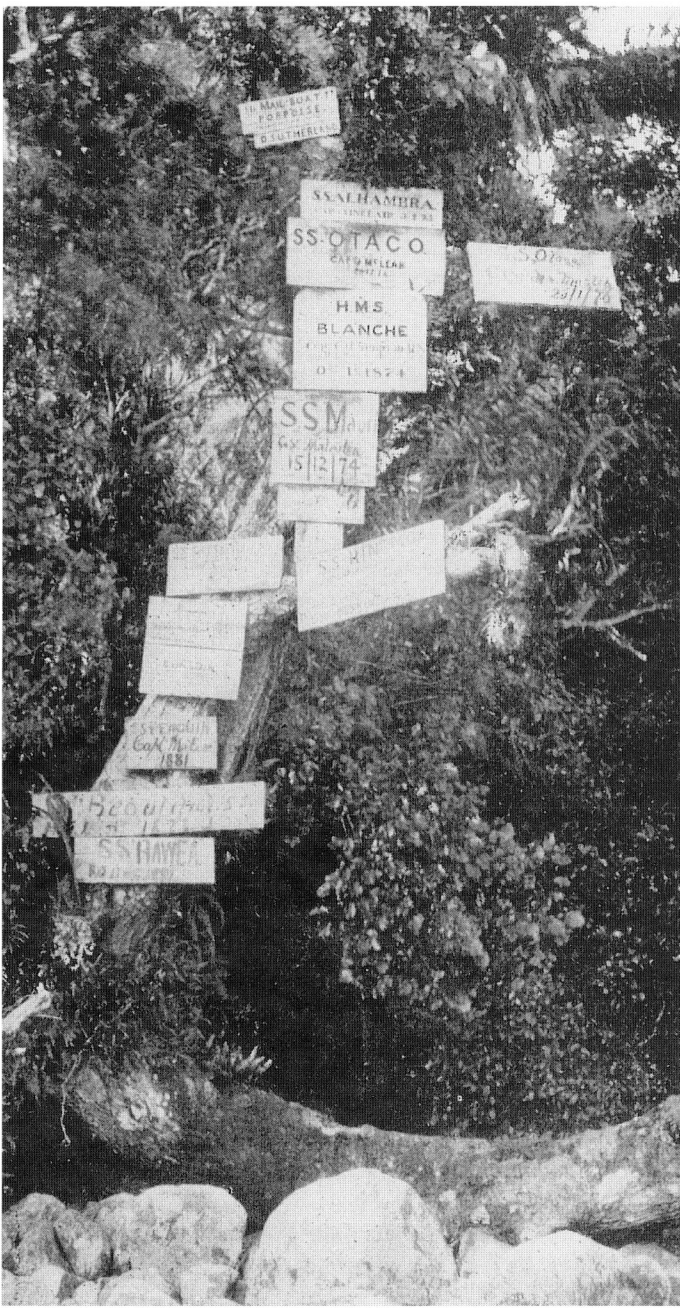

'Visiting cards' of early cruise ships nailed to a tree at Cemetery Point. *(J. H. Richards)*

s.s. *Maori* (Captain James Malcolm) which visited Milford Sound in 1874. Painting by W. Forester. *(J. Churchouse)*

Some Early Cruise Ships

During his summer cruise in the cutter *Rosa* in 1889 geologist Robert Paulin landed at Cemetery Point and examined the "visiting cards" of some early cruise ships to come into Milford Sound. Their names and dates were painted individually on to boards nailed to a large tree trunk and were recorded by Paulin as follows:-

HMS *Blanche*		1/10/74
ss *Hinemoa*,	Capt. Hoskins	5/5/77
ss *Hawea*		30/12/77
ss *Rotorua*,	Capt. Carey	6/1/79
ss *Penguin*,	Capt. Malcolm	1881
ss *Waihora*		30/12/83
ss *Napier*		21/7/85

HMS *Blanche* (Captain C. H. Simpson RN) had the Governor Sir James Ferguson aboard and the government steamer *Hinemoa* brought the Governor Lord Normanby into the sound.

The government steamer *Stella* anchored in Freshwater Basin. The old mouth of the Cleddau River (centre left) and Arthur Valley (centre right). *(Burton Bros)*

But Paulin's list appears to have been selective as an old photograph shows the "visiting cards" of other early ships prior to 1889, including the very first one to leave its name, ss *Otago* (Captain J. McLean), 2/2/1874; also ss *Maori* (Captain James Malcolm), Dec. 1874; ss *Alhamara*, 1877; ss *Dunedin*, 1874; and the government steamer *Stella*, which like its sister ship the *Hinemoa* used to service the lighthouses on the coast and was a regular visitor to the sound. Donald Sutherland who first called at the sound in a small open boat in December 1877 could not resist adding his name on a board on the very top of the list, "1877 Mail Boat Porpoise, D Sutherland".

On 14 February 1888 the *Hinemoa* called at the sound with Governor Sir William and Lady Jervois aboard. In a letter of apology to Donald Sutherland, who was away, Lady Jervois explains how she borrowed some tea from his store for a picnic, but later repaid it fourfold with "Hinemoa" tea.

An important omission on the "notice board" was the ss *Wanaka* which on 19 January 1877 initiated the Union Steam Ship Co's summer cruises of the West Coast Sounds. Her maiden voyage proved so popular that summer excursions on the *Wanaka* became a regular annual event. Later that same year her sister ship ss *Hawea* called at the sound as recorded by Paulin on his list. Six years later the company replaced the *Wanaka* with a much larger vessel, the

The *Waikare* sinking in Dusky Sound in 1910, putting an end to all summer cruises of the sounds until 1928. *(I. Williams)*

Tarawera, increasing the upper limit of passengers from 105 to 294. The *Tarawera* carried on until 1897, with two cruises most seasons, until she was replaced by the *Waikare*. Unfortunately the *Waikare*, after clearing Milford Sound, struck an uncharted rock in Dusky Sound on 3 January 1910 and sank. Although all lives were saved the loss of the *Waikare* put an end to summer cruises until 1928.

Sutherland's House

Paulin landed on the beach at Freshwater Basin where Sutherland had built his house in 1878 and he gives us an interesting description of the dwelling. "The house stands about 100 yards from the water and is made of wood. It is well and strongly built and has three rooms. The outer door was open and we went in. We found everything very clean and neat [inside with] wood laid in the fireplace and many objects of interest arranged tastefully about the room. On a table were several letters for the government steamer [either the *Hinemoa* or *Stella* which called every three months]. Behind the dwelling were some outhouses, one of which was fitted up for a forge and contained a large and good collection of tools, well kept. On a carpenter's bench was a diary evidently meant to be seen, and it was perused by some of the men."

"There was a small garden at the back of the house, [but] it struggled for existence with a mass of weeds and young native growth. Also roses, rhubarb,

Sutherland's house at Freshwater Basin with Sutherland seated on tree trunk. *(Alexander Turnbull Library)*

peas and strawberry plants, the latter had a good show of fruit not yet ripe. I went for a ramble through the bush [behind] where I got a good look at a saddle-bird [saddle-back, now extinct on the mainland], a beautiful, reddish-brown bird with a dark bar across its back and with red wattles."

Later he met Sutherland who he describes as "tall, heavily built, with a fresh complexion and bright blue eyes. That Sutherland is a man of taste is evident to anyone who has been in his house."

In an interesting comment on Sutherland's explorations of the area Paulin writes: "His surveys of the district show considerable ability in one who has not been trained in this work. I have no doubt", continues Paulin, "that before long there will be an hotel at the head of the sound, somewhere near where Sutherland himself is. Sutherland will most likely be the landlord with boats and guides to the mountains. Tourists will come to far-famed Milford Sound in large numbers [to see] one of the wonders of New Zealand", he prophesied.

"From our anchorage [off Sutherland's house] we were encircled by views, any one of which would suffice in Europe or America to attract crowds of tourists annually to the spot. The remarkable outline of Mitre Peak, the most strikingly shaped mountain in New Zealand; the majesty of the Bowen Falls, a vibrating, foaming pillar of water; the towering rock face of the Sheerdown Cliffs; the [great glaciated dome] of Pembroke rising majestically from the sea."

At the time of Paulin's prophesies, the Milford Track had been discovered only a few months previously and still had to be developed. The road to Milford Sound was 60 years away and aeroplanes hadn't even been invented. The only easy access to Milford Sound was by cruise boat but then at considerable expense.

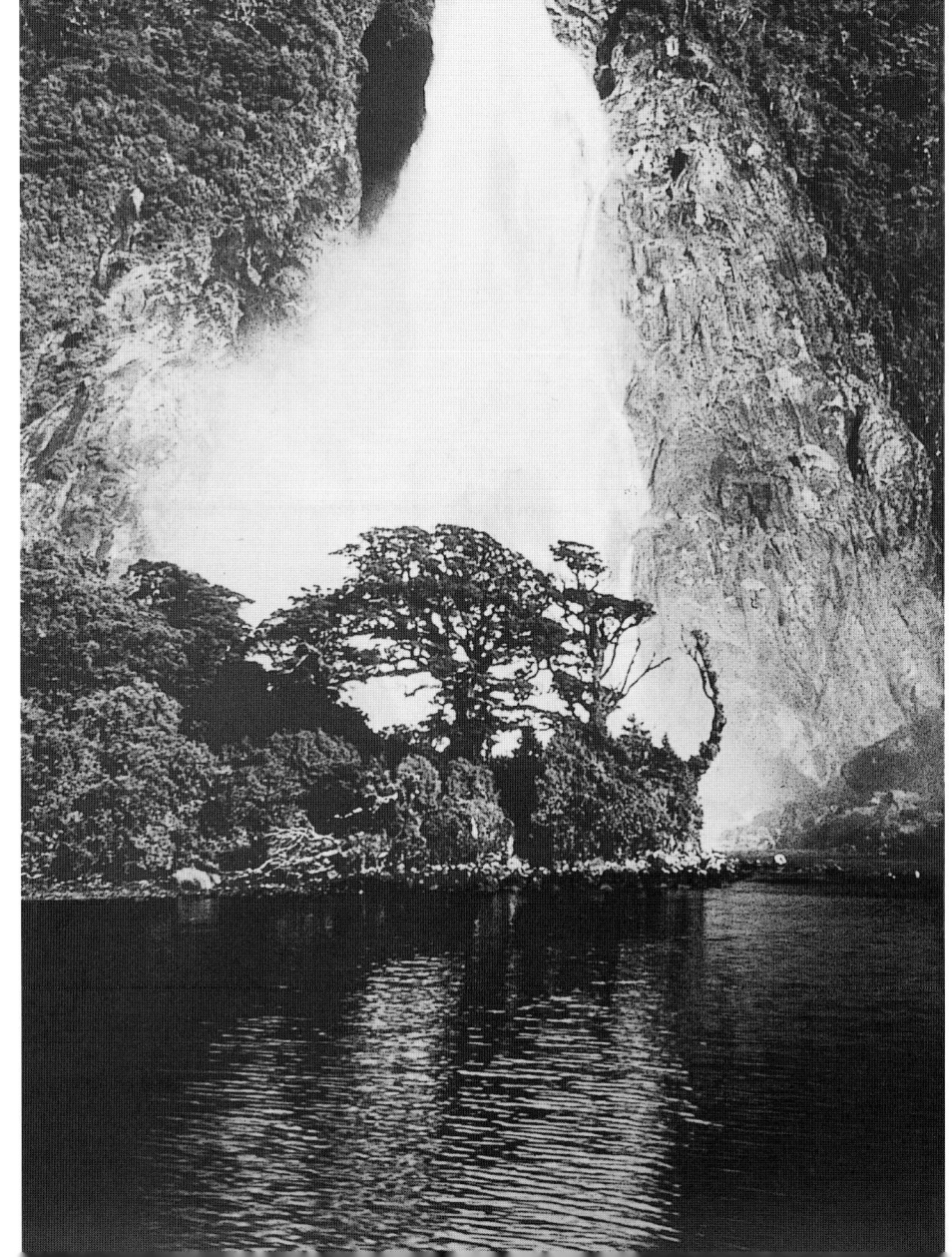

The Bowen Falls which Robert Paulin described as "a vibrating, foaming pillar of water". *(J. Hall-Jones)*

CHAPTER 2
The hermit of Milford Sound

I don't want to sound my own trumpet too much, but this is a bully run for a man in an open boat in 10 hours.
Donald Sutherland, 1877

Dusk was gathering as an open sailing boat slid silently through the sea towards Milford Sound. Entering the deep fiord the lone sailor continued up the narrow channel beneath the towering seacliffs, the snow-capped mountains contrasting strangely with the sea. Donald Sutherland had left his camp in Thompson Sound on the morning of 1 December 1877 and arrived that same evening at the head of Milford Sound. A distance of almost 100 kilometres it had taken him only 10 hours. With justification he wrote: "I don't want to sound my own trumpet too much, but this is a bully run for a man in an open boat in 10 hours."

On finding signs of Maori the veteran of the Maori Wars prudently erected his tent on a small island in the mouth of the Arthur River. Continuing up the river he discovered and named Lake Ada, "after a girl he had known in Scotland". Returning to the sound he crossed to Freshwater Basin where he noted that a little shelf of land would make a likely site for a hut "and marked it out".

Leaving a message in a bottle

Donald Sutherland (left) and two fellow prospectors "on guard" outside the "Esperance Chalet, Kennedy Street", Sutherland's original slab hut on the waterfront at Freshwater Basin.

in the Maori Wars as a corporal in the scouts. Drifting south the wanderer set sail from Dunedin in a small open boat, the *Porpoise*, with only a dog for a companion to arrive at Milford Sound on 1 December 1877.

The *City of Milford*

A few weeks later (it was then 1878) Sutherland returned to Milford Sound and began building his hut on "the shelf of land" at Freshwater Basin (the site of the present tourist centre). The "Esperance Chalet" as he grandly named his slab hut with its thatched roof was just above the shoreline with a sea wall of rocks in front. By 1879 he had built two similar huts a little up the hillside behind, the upper one also of slab timber, the middle one of pungas, both with thatched roofs. Each hut had its own paper and mail box for the delivery service by the *Stella* every three months. 'Streets' were 'laid out', with Rotorua Street at the upper level and Kennedy Street along the waterfront. During the 1880s he extended the "Esperance Chalet" adding on a verandah,

Donald Sutherland with his dog "Groatie" standing outside the upper of his three huts at the "City of Milford". Arthur Valley in background. *Burton Bros*

hanging to a tree on Cemetery Point he headed north to Jacksons Bay. The message was picked up three weeks later by the cruise ship *Hawea* and reads:

"Milford Sound, Dec. 9, 1877; all well. I leave here for Jackson's Bay, call into Big Bay – two dogs, plenty tucker, but short of baccy."

It ended in a flourish with "Anno Domini, 1877. Suaviter in modo fortiter in re. Vivat Regina. D. Sutherland, captain, mate and cook, dog passenger and live stock."

Born in Wick in the far north of Scotland Donald Sutherland had chosen a life of adventure. As a lad of 16 he enlisted in the Scottish militia and while still in his teens he joined Garibaldi's patriotic army to fight in Italy. Then he worked his way out to New Zealand as a seaman on a sailing ship and fought

The well-known photographer Alfred Burton (right) seated in the porch of Sutherland's upper hut. Note box for papers and letters. *Burton Bros.*

The "Esperance Chalet", March 1887. The original hut has been extended by adding a verandah and corrugated iron roof. Sutherland standing in the dinghy, *Milford Belle,* on right. The whaleboat with sail is the *Try Again,* in which Captain Brebner and three prospectors later perished. *Burton Bros*

Right: Donald Sutherland in his "18 foot" dugout canoe in which he explored and charted Lake Ada in 1880. *Burton Bros*

John McKay", an experienced prospector living at Big Bay, inviting him to come south by steamer and join him at Milford. Meantime Sutherland "set sail again for the southern sounds" leaving a note for McKay in case he should turn up in his absence. Some weeks later on his return to the 'city' Sutherland found McKay in his hut and "together we commenced prospecting in and about the sound, continuing thus for about a year".

Knowing that the Lake Wakatipu County Council was seeking a direct route through to Milford, the two prospectors set off in July 1880 to Queenstown (via Martins Bay and the Harris Saddle) to ask for "a little assistance". A sympathetic council granted them 40 pounds ($80) cash and supplies for six months.

After a brief look at the lower Cleddau Valley they hauled their boat over to the mouth of the Arthur River another room and replacing the thatched roof with corrugated iron. This was the three-roomed house described by Robert Paulin in 1889. A flagmast was erected and a stone pier built out from the waterfront. With all these major works going on the settlement had obviously reached urban status and quite rightly it became known as the "City of Milford". Truly, great things were expected of it!

About nine months after Sutherland settled at Milford he "sent word to

and "cut a track up [the true right bank of the river] to Lake Ada. We made a canoe 18 feet long", Sutherland recounted later, "in which we explored the lake and all its branches, taking soundings at various parts of the lake. Shifting all our belongings up the Poseidon River [Sutherland's name for the upper Arthur River] as far as we could by boat we made a head camp from which we prospected the rivers and creeks", naming the McKay Falls after John McKay.

Then on 10 November 1880 they obtained their first view of a high waterfall cascading down a sheer face of rock in three great leaps. Naming it the Sutherland Falls Sutherland estimated that it was "between 3,000 to 4,000 feet high". A generous figure which he later increased to "5,700 feet", but which surveyor C. W. Adams eventually cut back to the correct height of "1,904 feet" (580 metres).

During their exploration of the upper Arthur Valley the two explorers also

Left: Sutherland's chart of Lake Ada, 1880, showing his various soundings of the lake and the lagoon above. Also his names, Joe's River, Giants Gate, Terror Peaks and Poison Creek. *(Mrs A. S. Rose, Hocken Library)*

Right: Mt Balloon which Sutherland named "because it was sticking up out of the mist like a balloon". *(Otago Settlers Museum)*

The McKay Falls, named after Sutherland's companion John McKay in 1880. *(L. Sanson)*

The Sutherland Falls, which Sutherland and McKay discovered on 10 November 1880. *(J. Hall-Jones)*

named Mt Balloon "because it was sticking up out of the mist like a balloon".

In a letter dated 30 December 1880 (published on 21 January 1881 in the *Lake Wakatip Mail*) Sutherland reported that during October and November 1880 he and McKay had followed up the Arthur Valley from Milford "to further explore the south pass [see next chapter] but found that this pass would go too far south on Lake Te Anau to be of any practical use to your district [the Lake Wakatipu County Council] at present. After having returned from the pass we followed up the long valley [the Joe Valley, which Sutherland named after his dog] to a pass but here too the water on the east falls to Te Anau."

It was about this time (1880) that Sutherland and McKay were joined at the 'city' by two brothers, John and for a short time Albert, sons of Captain James Malcolm of the coastal steamer *Maori*, on the understanding that their father would keep the "city" supplied with provisions. In Sutherland's whaleboat *Porpoise* the prospectors ventured out on to the coast looking for gold, greenstone, "rubies" (garnets) and asbestos. But after an argument over the use of Sutherland's boat the brothers departed. By now McKay had come to the conclusion that there was no gold to be found at Milford and he decided to leave. But Sutherland had found his roots at Milford and he was to remain there for forty years.

In 1882 Sutherland was visited by the Invercargill artist, Samuel Horatio Moreton, and the photographer, W. P. Hart, and he took them up the Arthur Valley to see the Sutherland Falls. The two visitors had doubted Sutherland's description of his falls but they were "more than compensated for the trouble" they had in getting there. "So wonderstricken were we both", wrote Hart, "that the whole time we were there [two days] I do not think that 20 words passed between us".

Hart's photographs and Moreton's paintings did much to publicise the spectacular waterfall and Sutherland's splendid isolation was soon to be disrupted by cruise ships with tourists demanding to see the now famous Sutherland Falls. Sutherland did his best to adjust to these invasions of his 'private domain' with a salute of gunfire or a salvo of rockets. But like many guides he became weary of the trivial questions of city dwellers, or 'ashfelters' as he called them, and some found him rather surly.

Left: Sutherland (right), (?) John McKay and dog Joe with expedition supplies at the "City of Milford". Together they explored the Arthur River in 1880 naming the McKay Falls, the Sutherland Falls and Joe's River. *(Burton Bros)*

Right; Sutherland's map of Sutherland Sound, 1883. *(Trans. NZ Inst.)*

Sutherland Sound

In 1883 Sutherland sailed the *Porpoise* down the coast to explore the *Acheron's* "Little Bay" as marked erroneously on its chart, but known to the sealers as "Little Bligh Sound". Following up a tidal estuary at the head of the bay he entered a "saltwater lake, six miles long and one mile wide", to discover Sutherland Sound. Continuing to the head of the sound he found that it was fed by two rivers, an open one which he called the Light River and one with a "tremendous ravine" which he called the Dark River. "The woods around the lake abounded with birdlife", he observed, "and wekas are especially abundant; scarcely less so are pigeons, kakas, kiwis, kakapos and roas [large kiwis]. Redbills and penguins are in great numbers on the shingle bar." Sutherland drew a neat and accurate map of Sutherland Sound which shows that he even took soundings around the sand bar at the entrance.

The following year he explored another bay further south, Cats Eye Bay, where he rowed his boat "two and a half miles up a saltwater river. Kakapos,

kiwis and roas are plentiful on the south side of the river", he reported, drawing a neat little map of the bay and the valley. He also found "some wreckage of a vessel and copper rings on the beach".

Attempt on Mitre Peak

In 1883 Sutherland and Moreton made a determined attempt to climb Mitre Peak, the first to do so. "We had long had an ambition to scale this beautiful peak", wrote Moreton afterwards, "and on 6th February [1883] we left our headquarters at Freshwater Basin and sailed over to Sinbad Gully. Having secured the boat we shouldered our swags for the 'road' up the gully". But they found the 'road' very rough going with huge glacial boulders and thick, tangled undergrowth to contend with and after six hours 'march' they camped for the night.

The next morning they set out early "without coats and only one biscuit each". From the head of the gully they began climbing the near vertical rock wall in "stocking soles" and "literally dragged ourselves up by the boratika" on to the western end of the Mitre Range. From there they looked back on the vast array of jagged peaks of northern Fiordland including Mts Tutoko and "Moreton" (?their name for Mt Madeline). By now it was late in the day and stormclouds were gathering. They descended a little to shelter in the lee of the peak, but that night they were caught in a snowstorm. The next morning they reached their camp "thoroughly benumbed and drenched through and through, after spending a night out to be remembered" and having survived 24 hours on only one biscuit each. But their ordeal was not over yet. Their campsite was flooded out and they had to wait patiently for the floodwaters to subside. They eventually reached their boat and the safety of their "headquarters".

Moreton records that "we left a momento of our ascent on the peak in a small phial with our names, the date and a red handkerchief". It was not until next century that Mitre was finally climbed.

Painting in 1879 (possibly by Samuel Moreton) of the "City of Milford" and Mitre Peak. To the left of the peak, Sinbad Gully and the western ridge of Mitre which Moreton and Sutherland climbed in 1883. *(Mitchell Library)*

Left: The artist Samuel Moreton who, with Sutherland, made the first attempt to climb Mitre Peak in 1883. *(Alexander Turnbull Library)*

Mitre Peak Climbed, But When?

Hitherto most people have simply accepted Monday 13 March 1910 as being the day Jim Dennistoun climbed Mitre Peak for the very good reason that this was the date that he gave in his own report of the ascent in the *Otago Witness* of 7 February 1912. But as pointed out by two later-generation climbers, Dr Lindsay Stewart and John Pascoe, that same day Dennistoun and his party were descending from Mt D'Archiac after their triumphal first ascent of that great mountain. Dennistoun returned to his farm at Peel Forest, arriving late on 15 March 1910. He was nowhere near Mitre Peak on 13 March 1910.

To report his first ascent of Mitre Peak in "1910" in the *Otago Witness* of 1912 would seem very late after the event, indicating the possibility of an error. Was he really meaning Monday 13 March 1911 instead of 1910? A check of the calendar shows that 13 March 1910 was a Sunday and in 1911 it was a Monday. To clinch the matter a search of Sutherland's visitors book confirms the year in black and white with the entry: "11-14th March 1911. Barbara and J R Dennistoun, Peel Forest. J. R. D. climbed Mitre Peak (first ascent) on 13th taking Joe

J. R. ("Jim") Dennistoun RFC who made the first ascent of Mitre Peak. *(The Peaks & Passes of J.R.D. Courtesy Joanna Martin)*

Beaglehole as far as the long fairly level ridge running into the face of the final peak."

Arriving at Milford via the Milford Track Dennistoun discussed the best approach to Mitre Peak with Donald Sutherland who, after his experience in Sinbad Gully, "strongly advised me to climb the big bushy knob facing Sutherland's and follow the ridge all the way along. On Monday 13th 1910 [now known to be 1911] Joe Beaglehole [a Milford trackhand] and I left Sutherland's at 6.30 [am] and rowed across to where the creek from Sinbad Gully enters the Sound. We started climbing at 7.30 [taking] plenty of tucker, a strong rope that Sutherland had lent us and a pair of india rubber sandshoes which I thought might be useful if we ever got as far as the final slabby rock [of the summit]. We made great progress up the big

Dennistoun's route to the summit was via the "bushy knob" in front, the dip beyond and then up the leading ridge. He returned via Sinbad Gully on the left. *(J. Hall-Jones)*

bushy knob. The bush was surprisingly open and we just romped up [until] we came to the big dip, 500 feet I would say, very steep and the bush getting thicker, scrubby stunted stuff". By the time they reached the open tops Joe, who was not a climber, had had enough and decided to stay put.

"At 12 o'clock I started off [for the summit] with my sandshoes in my pocket and nothing else. The [summit] ridge falls literally 4,000 odd feet sheer down on both sides. [Reaching] the end of the ridge I took off my boots [and put on] the sandshoes which gave a splendid hold on the rough solid granite, so different to the mountains round the Hermitage, for the final peak. I reached the summit at 1.15 and built a small cairn, putting a white linen handkerchief on it. The view was not very good but the sound looked splendid, the Bowen Falls looked very tiny and I could see grampus [dolphins] jumping round Sutherland's launch, which was just getting home." Returning to Joe they descended to the bottom of the dip where, wishing to avoid the climb of the bushy knob, "I made a great mistake" and dropped straight down into Sinbad Gully. It was dark before they struggled out to their boat and 10.30 pm by the time they arrived back at Sutherland's.

"It is a wonderful climb", he concludes, "and one rather has the feeling of being on top of a steeple 5,560 feet high! Start much earlier [than we did], take sandshoes and go by the way we went up", were his final words of advice.

Sadly Jim Dennistoun, an observer in the Royal Flying Corps, was severely wounded when his plane was shot down in flames over France. He died as a prisoner of war in a German hospital on 9 August 1916. The exploits of the conqueror of D'Archiac and Mitre are commemorated in a beautiful stained glass window depicting Mitre Peak in the Peel Forest Church.

On 1 March 1914 Edgar Williams and Jack Murrell, following Dennistoun's recommended approach, made the second ascent of Mitre Peak where they found Dennistoun's handkerchief inside the cairn that he had built.

Aerial view of the summit of Mitre Peak looking down on the head of Milford Sound, the Bowen Falls and the Cleddau River delta. In the immediate foreground is the "bushy knob" with Sinbad Gully on its right.

CHAPTER 3

The Mackinnon Pass

Mr Adams or Sutherland. Arrived 17th October 1888, all well. 4 o'clock sharp. Gone down river.
Q. McKinnon

Sutherland's map of the head of the Arthur (Poseidon) River, November 1880. Note his "South Pass to Lake Te Anau and Blyth Sd", his height for the Sutherland Falls and "Mt Balloon", but no "Balloon Pass". *(Mrs A. S. Rose, Hocken Library)*

Sutherland's South Pass

One of the most exciting moments during the whole research for this book was to be shown a map by Donald Sutherland of the Arthur Valley which clarifies, at long last, his explorations with John McKay during October and November 1880. Robert Paulin hints in his visit to Sutherland in 1889 that such a map might have been drawn but it was without any real expectancy that I checked with David MacDonald of the Hocken Library (a descendant of Sutherland) if any such map existed. I was both delighted and surprised when he answered in the affirmative and proceeded to produce it for me! David informed me that the map had been deposited recently in the library by a member of the family.

Sutherland's map which is dated November 1880, but added to in 1883, is tinted beautifully in 'forest' green and confirms his considerable map-making ability as mentioned by Paulin. It shows Sutherland's name of Poseidon River for the upper Arthur River above Lake Ada; his generous figures of 5,700 feet for the Sutherland Falls and over 9,000 feet for the surrounding mountains; his naming of Mt Balloon, Mt Hart (after the photographer whom he took to see the falls in 1882) and Mt Sutherland (which was later re-named by Sir Thomas Mackenzie after himself). Here too are his names of the McKay Falls and the Joe's River ("the long valley") which he explored and named after his dog.

But most importantly here is his name "South Pass" which Sutherland and McKay explored but found "would go too far south on Lake Te Anau to be of any practical use" to the Lake Wakatipu County Council. Whereas in the past Sutherland's "South Pass" was thought to have been synonymous with the Mackinnon Pass, it is revealed on his map as being at the head of the Green Valley branch of the Arthur River.

Sutherland in his report in the *Lake Wakatip Mail* in 1880 tells how he and McKay cut a track to the Sutherland Falls and the South Pass, which they ascended, in October 1880. On his map he adds a further note: "South Pass to

THE MACKINNON PASS

The explorer Donald Sutherland whose "South Pass" at the head of the Arthur Valley is now known to be the pass leading through to Sutherland Sound. *(Southland Museum)*

Right: The razor-back ridge of the Mackinnon Pass showing today's track zig-zagging up from the Clinton Valley, then along the ridge to descend into the Roaring Burn and Arthur Valleys. Photographed from Mt Hart with Mt Balloon at the opposite end. Lake Mintaro at the head of the Clinton Valley. *(Alexander Turnbull Library)*

Lake Te Anau & Blyth [Bligh] Sd". Sutherland also told the government geologist Alexander McKay about his discovery of the South Pass and in 1883 McKay reported the pass as being "at the source of the more westerly branch [Green Valley] of the [Arthur] River, leading in the direction of Bligh Sound by which it is hoped communication may be established with one of the western arms of Te Anau Lake".

Although Sutherland was not to know, the valley he saw on the far side of South Pass was the Light River Valley leading down to Sutherland Sound, not Bligh Sound. By following this valley down and then traversing the "tremendous ravine" of his Dark River gorge he would have reached the Worsley Arm of Lake Te Anau, albeit in a very roundabout way.

After Quintin Mackinnon crossed the Mackinnon Pass in 1888, Sutherland claimed that this was the same south pass that he and McKay had been on in 1880 naming it Balloon Pass after Mt Balloon, but that it was "too far south on Lake Te Anau to be of any practical use" to the Lake Wakatipu County

Mackinnon and Mitchell cross the Pass

On 10 July 1888 Quintin Mackinnon wrote to Adams: "Re track up the Clinton, if I blazed track to saddle, I would certainly push on to Sutherland's track before returning". The letter confirms that Mackinnon was confident of a route over the pass before he actually crossed it. Mackinnon was employed by the government to blaze a track up the Clinton Valley from Lake Te Anau for the sum of 30 pounds ($60). On 7 September 1888 Mackinnon and his mate, Ernest Mitchell of Manapouri Station, left for the head of the lake and set up

Mackinnon Pass from the Clinton Valley with the sentinel tower of Mt Balloon at the right end. *(J. Hall-Jones)*

Below: Quintin Mackinnon (left) and Ernest Mitchell who blazed a track up the Clinton Valley and crossed the Mackinnon Pass on 16 October 1888. *(Alexander Turnbull Library)*

Council. Later in 1907 he enlarged on this whole subject in a letter to the *Lyttelton Times*, adding further to the confusion. But this is of course evidence in retrospect and now that we know where the true South Pass is it cannot be accepted. A study of Sutherland's 1880-83 map shows both Mt Balloon and Mt Hart (which lie on either end of the Mackinnon Pass) clearly marked in but without any name or suggestion of a pass in between them. Also, although the junction of the Roaring Burn (the stream leading up to the Mackinnon Pass) is marked in, there is no further continuation of the burn, nor detail of this side valley off the Arthur Valley, nor any hint that he followed it up.

At the same time it should be mentioned that in 1887 when Samuel Moreton and W. Y. H. Hall were planning to try and get through to Milford by way of the Clinton Valley, Sutherland advised them to use Mt Balloon as a guide. Unfortunately Moreton and Hall's expedition had to be aborted because of high flooding in the Clinton Valley. One year later Mackinnon must have blessed Sutherland's advice as Mt Balloon sticks out like a guiding beacon as you ascend the Clinton Valley.

a base camp on the bank of the Clinton River. As they blazed their track up the Clinton Valley they shifted their camp forward each day, returning at one stage to Te Anau Downs Station to top up with supplies.

"It was fearful work", wrote Mitchell afterwards, "through 'lawyers' and over rocks, the ground getting worse as we got higher" in the valley. It rained continually for several days and everything in the tent got soaking wet. Then the sun came out and their blankets became "a moving mass of blowflies". Mitchell's dog raided two blue duck nests sucking all 14 eggs dry and doing the explorers out of a feed of pancakes. But they were both carrying guns and they shot five kakapo for tucker instead. They also tried kiwi, but found the "flesh far too rank for eating".

As they approached the pass at the head of the valley they came to a pretty little lake which they named "Lake Beautiful" (later renamed Lake Mintaro). "It was the most lovely lake I have ever seen", wrote Mitchell, "with bush on one side and tussocky slopes on the other. Surrounded by a great amphitheatre of mountains it lay at the foot of the saddle, with lots of paradise ducks on it."

On 16 October 1888 they hauled themselves up through the scrub and snowgrass on to the top of the pass. Unfortunately it was raining and the visibility was poor, but they groped their way along the pass towards Mt Balloon and descended about halfway down the far side where they camped for the night, fireless and supperless. The next morning they scrambled down to the bushline and followed the left bank of the Roaring Burn down to a shingle beach where they killed and grilled a blue duck.

Continuing along the bank of the Roaring Burn they intercepted Sutherland's track close to his slab Beech hut and left a message set in a stick:

> Mr Adams or Sutherland
> Arrived 17th Octr 1888
> all well. 4 o'clock sharp
> Gone down river
> Q. McKinnon

Amazingly, the message which was written roughly in pencil on a torn piece of paper, survives today and is a treasured possession of the Hocken Library.

Adams' Survey Expedition

In 1888 Charles Adams, the Chief Surveyor of Otago, decided to visit Milford Sound with a view to carrying out a survey of the Arthur Valley, measuring the height of Sutherland's Falls and finding a route overland to Lake Te Anau. Prior to his visit he commissioned Sutherland to cut a track to

"Lake Beautiful", Mitchell's original name for Lake Mintaro. *(J. Hall-Jones)*

Mackinnon's historic message to Adams or Sutherland on 17 October 1888 is carefully preserved in the Hocken Library. *(Hocken Library)*

the falls, build a slab hut there (Beech hut) and a boatshed at the foot of Lake Ada (Bunger hut), all for the princely sum of 50 pounds ($100). At the same time he also asked Quintin Mackinnon of Te Anau to blaze a track up the Clinton Valley from the head of Lake Te Anau for the payment of 30 pounds ($60).

The survey party, which arrived on the SS *Ohau* at Milford on 27 September 1888, consisted of Adams as leader, his son "Eddy" (later Dr C. E. Adams, the government astronomer), surveyor G. A. Stables and W. Wyinks. Accompanying the expedition were two parties of photographers: one representing Morris of Dunedin (the talented photographer Fred Mintaro Muir, architect John Forrester and warehouseman Percy Brodie); the other representing the famous Burton Bros of Dunedin (Alfred Burton, G. Moodie and R. Ferguson). Also on board were the politician-explorer Thomas (later Sir Thomas) Mackenzie and his companion William Pillans, whose avowed intent was to independently find a route through to Lake Te Anau. Sutherland's visitors book and Forrester's diary would suggest that there was a certain amount of tension between the surveyors and the photographers. This was not exactly helped when young Eddy Adams, innocently but apparently on his father's instructions, entered the names of everyone in the visitors book without first seeking their permission and rather pointedly placed the photographers lowest in the 'batting' order. To make matters worse he misspelt some of their names! The latter took umbrage at this adding a note disassociating themselves from the entry and poking a little fun at Adams' night attire –

> Then at night
> Twas quite a sight
> to see the survey chief in
> night cap red
> and bag for head.

The Sutherland Falls expedition at Milford Sound, 1888. The bearded man (centre) with billhook on knee is Sir Thomas Mackenzie. Seated on the bow of the boat is W. S. Pillans and in this same boat (with top hat) is chief surveyor C. W. Adams. *(Burton Bros)*

But the Chief Surveyor had the final word when he arrived at the

Sutherland Falls by torchlight in the middle of the night and turfed the photographers out of his tent back into their own.

Sir Thomas Mackenzie Explores

"Off to Te Anau", wrote Thomas Mackenzie with a confident flourish on the very day that they arrived at Milford. In the same entry he proclaimed: "Red letter day for Milford, 27 Sept. 1888: Mr Pillans liberated 160 Loch Leven and Brown Trout in the Claddau [sic] River". Indeed Pillans and Mackenzie's progression up the Arthur Valley can almost be followed by their liberation of trout fry: "100 in the Arthur River on 28 September and 1,000 in the Poseidon River on 30 September."

By then they had met up with Sutherland, who had been working on his track and after viewing the Sutherland Falls they spent "a week [with Sutherland] exploring the headwaters of the Joe's River [looking] for a saddle to Te Anau. We found a saddle [in the Joe] which is at present quite impracticable because of snow and ice", recorded Mackenzie in the visitors book on their return to Milford on 12 October.

Disappointed with the Joe, Mackenzie and Pillans set out again, this time for the head of the Arthur Valley and taking Wyinks with them as a companion. "About two miles" past the Sutherland Falls they ascended "a fine pass to one of the sounds" (Sutherland Sound). The party returned to their camp below the Sutherland Falls and on their way back to Milford they were "delighted to find two trees blazed with McKinnon's initials and also a sheet of paper stuck upon the end of a stick" bearing the famous message.

The hour was late and Mackenzie's party camped on the spot for the night. The next morning they were up early and hurried on down the track hoping to catch up with Mackinnon and Mitchell. They found the two explorers camped at the head of Lake Ada having a well earned lie in.

The combined parties continued down Lake Ada in a "crazy" canvas boat to Sutherland's punga boatshed at the foot of the lake, where they met up with Charles Adams' survey expedition who were heading up the track to measure the height of Sutherland's Falls. An historic photograph shows the whole

Historic group photograph outside Sutherland's punga boatshed, "Bunger Hut", at the foot of Lake Ada. Quintin Mackinnon on left of theodolite and C. W. Adams on right. Then Ernest Mitchell and W. S. Pillans. Donald Sutherland seated far right. *(Burton Bros)*

group, including Sutherland, Mackinnon, Mitchell, Adams, Pillans, the surveyors and photographers, posed outside Sutherland's punga boatshed. Describing the boatshed the architect John Forrester informs us that it was "large, 10 feet by 15 feet, with a large open front and both the walls and roof were constructed of pungas. [Because of this] it was also known as Bunger hut", bunger being a local name for punga.

Mackinnon and Mitchell hurried on to Milford where Mackinnon wrote in Sutherland's visitors book: "21 October 1888. Found good available track from Te Anau to connect with Sutherland's Track at Beech [later Quintin] Hut. Found government maps very much out and the Hermit's explorations very much in." (According to Sutherland he had given Mackinnon "all his information about his explorations, two or three years previously".)

Mitchell departed by steamer for Dunedin and thence to South Africa where he joined the police force and rose to the rank of inspector. A hitherto unidentified photograph of Mitchell shows Mackinnon farewelling Mitchell before he sailed from Milford. A reporter who was there at the time describes Mitchell as "a splendid young fellow, quiet and unobtrusive". Born in Buncrana, Ireland, he "has spent some years working with his brother", William Mitchell, manager of Manapouri Station.

Having said goodbye to Mitchell, Mackinnon, now joined by Thomas Mackenzie, Pillans and the photographer Fred Mintaro Muir, returned over the pass to Lake Te Anau. This time Mackinnon struck snow on the top of the pass and the legs of the photographer's tripod were requisitioned for alpenstocks.

An historic photograph by Muir shows Quintin Mackinnon in the Clinton Valley pointing to the pass which he had by now crossed twice. Sir Thomas Mackenzie is seen holding a brace of kakapo and what with Mackinnon's pancakes made of blue duck eggs, the explorers certainly fared well on rare game! "Bird life abounded", wrote Mackenzie afterwards, giving an interesting list that included "saddle-backs, native thrush and red [orange] wattled crows; kakapo and kiwi were very numerous. White clematis festooned the tree-tops

Mackinnon (seated centre) farewelling Mitchell aboard ship at Milford. A previously unrecognised photograph of Mitchell who is seated beside Mackinnon (on right). *(Hocken Library)*

Right: Historic photographic of Mackinnon pointing to the Mackinnon Pass. W. S. Pillans seated and Sir Thomas Mackenzie holding kakapo. Photograph by Muir in the Clinton Valley. *(Alexander Turnbull Library)*

THE MACKINNON PASS

in great clusters. At one point [near the future Glade House] the flowers were so numerous that we named it Clematis Point."

Mackenzie, a great name-giver, named Lake Ida [Hidden Lake] after his wife; the Jervois Glacier after the Governor, Sir William Jervois; St Quintin Falls after their guide and Lake Mintaro after the photographer in the party. Concerning the name Lake Mintaro surely Mackinnon would have told Mackenzie of their original name of "Lake Beautiful" for this "most lovely lake". In which case why change it, particularly to a personal name? It would also be Mackenzie who named the pass after Mackinnon, who by now had crossed it twice. At the same time it would seem unfortunate that Mackenzie, with all his name-giving completely overlooked Mackinnon's companion on the first crossing, Ernest Mitchell..

Inevitably there was a Mt Mackenzie on the route - indeed two Mt Mackenzies for good measure - one in the Arthur Valley (originally Mt Sutherland) and the other in the Clinton Valley. But the latter was changed later to Mt Sentinel so as not to cause confusion. Concerning Mackenzie's acquisition of Sutherland's original name of Mt Sutherland, this probably explains Sutherland's entry of "Wind Bag" beside a cartoon of the politician in his visitors book (see Appendix A). Whatever, the two didn't exactly strike it off together and there are some caustic remarks by Sutherland against Mackenzie's name in the visitors book.

Adams measures the Falls

Adams' survey party had begun their work surveying around the sound by boat and then on 8 October they hauled their dinghy up the rapids of the lower Arthur River, "wading up to their waists in places", to enter Lake Ada and continue their survey there. After the historic meeting with Mackinnon and Mitchell at Bunger hut Sutherland guided Adams and his survey party up the track to Beech hut, where Adams set about his business of measuring the height of Sutherland's Falls. "After three weeks' work of cutting ranging lines, I succeeded in measuring the height of the Falls", he wrote. "I was very disappointed to find that they were only 1,904 feet high." Nowhere near the height of "5,000 feet" that he had been led to believe. "The water strikes the rocky precipice twice in its descent, forming three leaps, the upper being 815 feet, the middle 751 feet and the lower 338 feet."

Above right: Arrival at Mackinnon's base camp at the head of Lake Te Anau on 24 October 1888. Mackinnon standing beside kakapo on tent ridge pole. Captain Melville Duncan of Te Anau (left) and W. S. Pillans (right). *(Hocken Library)*

Below right: In this version of the scene Fred Mintaro Muir has taken Captain Duncan's place. The kakapo hasn't moved! *(Hocken Library)*

The survey party outside Sutherland's original slab Beech hut. C. W. Adams with top hat and axe outside door. "Eddy" Adams third from left. *(Alexander Turnbull Library)*

Right: The first map of the track was a painted one by the artist L. W. Wilson in 1889. Note "Bunger hut", "Slab [Beech] Hut" and Mackinnon's upper "Landing" in the Clinton River. *(L. W. Wilson)*

Although disappointed that the Sutherland Falls were only two-fifths of the height that he had been told he was nevertheless impressed by their grandeur. "I lay on the mossy bank", he wrote, "wrapt in contemplation of the majestic spectacle before me; which was sometimes in sunshine, sometimes in shadow, as the sailing clouds passed by. If it had been my lot to have discovered these falls I should not have given them my own name: I should have called them the 'Rainbow Falls'."

> *For in the drifting misty spray*
> *That drapes these rugged rocky walls,*
> *We see the bright prismatic arch,*
> *The glory of the Rainbow Falls."*

As he lay musing he cast his eyes upwards to "where the cataract shoots

out of the rocky spout, with the first leap of the mad waters into space". Describing the peculiar "diapason" sound of the falls as they plummet into the pool at the base, he explains that in calmer weather the water falls in an "unbroken sheet into the deepest parts of the pool" to produce the "thunder-tones of this great organ". But with a breeze the "falling cataract" is blown on to the "massive flat-topped rock" above the surface of the pool to produce a higher tone.

Adams departed from Milford leaving his men to carry on with the survey of the track. Sutherland, as we have seen, had cut his original track up the easier going terrain of the right bank of the lower Arthur River to Lake Ada and had built his punga boatshed (Bunger hut) near the outlet of the lake on that side. A beautifully painted map of the track in 1889 (the first every map of the track) by the well known artist L. W. Wilson, shows Sutherland's original track from the "landing" to "Bunger hut". But the surveyors decided to shift the line of the track over to the opposite bank of the river (where it is today), because this would give access to the western side of Lake Ada where the track around the lake (today's track) was to be formed. Later we will see how this new track up the river from Sandfly Point was constructed by convicts. With the realignment of the track on the lower Arthur River a new boatshed and jetty had to be built at the foot of the lake, at what became known as Doughboy. Later the Doughboy jetty became the lower terminal on the lake during that easy era when track walkers were ferried down the lake by boat. The Doughboy wharf is still used occasionally for transporting supplies, but the old Doughboy hut has crumbled away. Its foundations can be seen in the little grassy clearing at the beginning of the pathway to the wharf.

A similar shift took place at Sutherland's Beech hut (which is shown as "Slab Hut" on Wilson's map). Being the experienced bushman that he was Sutherland sited his hut on the steep hillside above the present Quintin huts so that it wouldn't be flooded out. Constructed of "beech slabs with eight bunks and a fireplace" it was "12 feet long, 10 feet wide, with a wall 7 feet high" and had a high gabled, thatched roof so that the notoriously heavy rain of the area could run off easily. But the surveyors wanted the hut more in line with the track to the Sutherland Falls so they dismantled it and shifted it down on to the flat below to the new Beech huts (now Quintin huts). Likewise they realigned Mackinnon's steep descent down the left bank of the Roaring Burn to the right bank (today's track) so that the track could make a wider and more gradual sweep down from the pass.

In the late 1950's William Anderson, the veteran track manager at Quintin huts, located the site of Donald Sutherland's original Beech hut and constructed a second hut of beech slabs (albeit of different dimensions) on the site as a memorial to the man who pioneered the famous Milford Track.

Sutherland's original Beech hut. Photograph by Fred Muir who is posed outside. Mt Balloon on skyline.
(Alexander Turnbull Library)

William Anderson's reconstruction of Sutherland's slab Beech hut.
(J. Hall-Jones)

CHAPTER 4

Quintin Mackinnon

Our guide was a stout, broad-shouldered Scot whose bronzed and weather-beaten face spoke of determination, endurance and dogged perseverance under difficulties.
W. McHutcheson, 1891

Born in Shetland in 1851 Quintin Mackinnon was the son of a Presbyterian minister. Although later in New Zealand he signed his name "Quintin McKinnon", his son confirms that the correct spelling of the family name is Mackinnon. In his twenties Quintin Mackinnon fought for the French in the Franco-Prussian war before coming out to New Zealand. A cadet surveyor and a keen footballer he played with the celebrated Otago rugby team which toured New Zealand in 1877 with an unbeaten record. The historian Robert Gilkison recounts that Mackinnon, "although somewhat small [in stature] was powerful and on one occasion during a match he threw [Gilkison] over his head".

"Poor Mackinnon", Mrs Katherine Melland of Te Anau Downs Station informs us, "ruined himself [and his marriage] with intemperance. He came to this lovely, beautiful lake [Te Anau] to forget and be forgotten." Arriving in 1885 he built his log cabin at Garden Point on the remote western shore of Lake Te Anau, which was just about as far away from civilisation as he could get. "He was quite safe [from temptation] at Lake Te Anau and he worked for us at busy times of the year."

The fascination of exploring the rugged wilds of Fiordland soon captivated Mackinnon and in 1887 he and George Tucker discovered a route through to Caswell Sound. He sent a report of his discovery with a little sketch map to Chief Surveyor Charles Adams in Dunedin. It was probably as a consequence that Adams employed Mackinnon to blaze a track up the Clinton Valley in 1888. A job that resulted in his momentous first crossing of Mackinnon Pass.

Appropriately Mackinnon became the first guide on the Milford Track. William McHutcheson in his book *Camp-life in Fiordland* gives a lively and at times hilarious account of his guided trip on the track with "Mac" Mackinnon in 1891.

Clinton Hut

In those days prior to Glade House, Milford Track walkers were dumped at the mouth of the Clinton River by the lake steamer *Te Uira* and then had

Mackinnon's log cabin at Garden Point, on the western shore of Lake Te Anau. *(C. Ross)*

to find their way up to the Clinton hut on the top of a mound on the west bank. "We clambered up fifty or sixty feet of corduroy stairway and presented ourselves at the door of the Government shelter house", writes McHutcheson. There they were welcomed by Mackinnon's agent, the artist Captain Melville Duncan of Te Anau, who "tumbled out of bed without grumbling" at the ungodly hour of one o'clock in the morning.

"The house we found ourselves in was a rough but comfortable two-roomed cottage, built of sawn timber, roofed with iron, and set in the midst of a little clearing on the hillside, 50 feet above the roaring Clinton River. Round the sides of the room ran a row of rough bunks, long enough and wide enough to admit of two, sleeping 'heads and tails' together. The furniture consisted of a plain deal table or bench nailed along under the window, a couple of wooden stools, a few tin dishes and cooking utensils, and – what do you think? Why, straddling its long aristocratic legs among a heterogeneous assortment of plebian billies, swags, candle-boxes, and empty kerosene tins, stood a refined, high-bred easel, with unfinished picture, palette and brushes. Instinctively we turned to the other corner to look for the piano, but all that met with the eye was a dilapidated Crimean shirt and a pair of woollen socks hung up to dry."

An early photograph shows the old Clinton hut on the crest of the mound, with the Clinton River below and the lake beyond. Today the remains of the "corduroy stairway" can still be found. Also some relics of the hut.

Track party preparing to leave Clinton hut in 1895. Standing extreme left is Tom Fyfe, who during the previous year led the first ascent of Mt Cook. Seated below him is another climber, Malcolm Ross. Together they attempted to climb Mt Balloon, but were forced back by bad weather.

Left: Clinton hut on the west bank of the Clinton River. Head of Lake Te Anau in background. *(Alexander Turnbull Library)*

Mackinnon's Hut

After a couple of nights at the Clinton hut their guide "Mac" Mackinnon arrived and McHutcheson gives us an eloquent description of the famous explorer.

"'Mac' proved to be a stout broad-shouldered Scot from the Kingdom of Argyle, every lineament of whose bronzed and weather-beaten face spoke of determination, endurance,

and dogged perseverance under difficulties, while the quick glance and ready twinkle gave evidence of the fund of natural wit and good-humour that lay beneath. His dress, as I have hinted, was peculiar. A pair of loose flannel knickerbockers gave the wearer somewhat the appearance of having lately outgrown his clothes. A coloured shirt hung in true bush fashion outside his pants, while round his waist were strapped a leathern pouch and ponderous two-edged hunting-knife. With a 30lb swag on his back and a gun over his shoulder, and the whole surmounted by a flaming red billycock hat and feather, 'Mac' would have passed anywhere as a distinguished Italian brigand looking for a job, and almost certain to find employment at the first time of asking. The red billycock was really immense. It had been the parting souvenir of some former tourist, and, in addition to the picturesque air it lent the wearer, served subsequently as a never-failing beacon to guide us through the bush."

With "Mac" in the lead they set off up the west bank of the Clinton River, which was the original start of the Milford Track prior to Glade House. "We formed up into single file", recounts McHutcheson, "and sallied forth into the depths of the primeval forest of Fiordland. Two miles from the start we passed another shelter-house, built on high piles [Mackinnon's hut] to be secure from floods. The guide usually boats his party thus far, and so affords them a grand river view, besides [avoiding] some of the worst travelling [through swamps] in the valley. However, we had been unable to get the big whale boat over the Clinton bar that morning, the river being too low." (Mackinnon's upper 'landing' is

Quintin Mackinnon in "Italian brigand" garb, gun and hunting knife. *(Hocken Library)*

A fine sketch of Mackinnon's two mile hut by D. C. Hutton in 1892. Note how it is mounted on high wooden piles to protect it from floods. *(Hocken Library)*

A photograph of Mackinnon's hut confirms the accuracy of Hutton's sketch. *(Hocken Library)*

Another sketch by Hutton shows the interior of the hut, its bunks and store-cupboard in the roof. *(Hocken Library)*

driven firmly into the ground. The kitchen was a 'sort of addendum or lean-to' to the dining room and of the same airy construction, but boasted a great stone fireplace roomy enough to roast the proverbial ox in."

Interestingly McHutcheson uses the correct spelling for pompalona which nowadays is commonly misspelt pompolona. Mackinnon was famous for his pompalonas, "a sort of fried scone". Unaware of the recipe the party watched in consternation as Mackinnon dived into a tin, fished out a couple of candles and tossed them into the frying pan to make his scones. But all was well for the candles were made of mutton fat!

After a cheery wake-up call of "Roll up the battalion for breakfast" and a good plate of "burgoo" the party set out on a long day trip over the Mackinnon

Mackinnon's camp at Pompalona. A watercolour by L. W. Wilson in 1889. *(Hocken Library)*

marked on L. W. Wilson's painted map.)

Mackinnon's hut was situated on the west bank of the river opposite the junction of the Neale Burn and the Clinton and offered a fine view into the valley of the former. Thanks to the artist D. C. Hutton we have two excellent sketches of the exterior and interior of Mackinnon's hut in 1892, showing it resting on its "high piles" and also the bunks inside. Later when Glade House was built Mackinnon's two mile hut fell into disuse and crumbled away. In 1977 Phil Turnbull, then manager of Glade House, showed me some remains of the "high piles", but these have since rotted away. Today the site is marked with a sign near the turn off for the new Clinton huts.

Pompalona Camp

Some eight miles past Mackinnon's two mile hut McHutcheson's party came to his Pompalona camp, where they spent the night in a large sleeping tent, well covered with "dry fern" on the floor. The "dining room was a large calico fly stretched over a rough slab table; [also] slab stools with rough legs

Pass and back. As they headed towards the pass the "landmark shaft" of "black polished granite" of Mt Balloon dominated the skyline. Coming to "the lakelet" of Mintaro they passed the "Government shelter-house", with its corrugated iron roof and shot a brace of teal and paradise duck on the lake.

After passing through the "fairyland" forest of twisted, gnarled trees festooned with lichens they began to ascend the pass. "The slope being too steep for a straight climb we crawled up in a sort of zig-zag fashion, mostly on all-fours." They were "knee-deep" in snow when they gained the summit but they were rewarded with a magnificent view. "Round us in all directions huge frowning crags rise sheer up out of the valleys below. Great weather-beaten peaks where the lightnings play; peak upon peak of naked granite, where the storm-clouds brood." Far below lay the Arthur Valley with its "tiny rivulets wending their way through the bush and pastures green".

Emptying the snow from their boots and wringing out their socks they "rebooted" and descended Mackinnon's steep track on the left bank of the Roaring Burn to reach the Beech huts. The huts are "two rough and ready, but comfortable enough cottages of one room each, with an open fireplace and a double row of sleeping bunks", against the walls. "The door, mantel and ceiling were largely ornamented with carved initials and names of former occupants." They soon had a billy boiling on the open fire and stretching themselves "luxuriously round the slab table", they proceeded to enjoy their lunch of ship biscuit, preserved fish and "recently deceased sandflies".

They continued on through a "delightful avenue of stately pines" (surely beech trees) towards the Sutherland Falls, the "thud, thud" and "swish, swish" of the waters growing louder as they approached. Like Adams before him, McHutcheson stood entranced. "The longer one stands before the mighty column of descending water the more he is impressed with its majesty and power."

By now the day was racing on and it was time to climb back over the pass to Pompalona camp. "We struggled back into Pompalona just as the shades of evening were beginning to close in upon us." It was raining when they woke next morning but they sloshed their "aqueous way" down the valley to Clinton hut.

Taking a break. Two pioneer trekkers on the Milford track. A sketch by R. Haweridge in 1897.

Mackinnon (seated) in his whaleboat *Juliet* in which he later perished. Note long steer-oar. *(Hocken Library)*

"We arrived at the lake camp between three and four o'clock in the afternoon, to find that our good friend the captain [Melville Duncan] had, in anticipation of our coming, made everything nice and snug, and had a grand drying fire crackling up the wide open-mouthed chimney. A plunge in the icy-cold lake, clothes and all, to wash off the mud, and a vigorous rub-down to restore circulation, dry clothes once more, and in less than an hour we were all gathered round the fire, anxiously sniffing the savoury odours emitted by sundry corpulent billies suspended over the log fire. By this time we had taken stock of the Clinton Chalet once more, and noted that the captain, in honour of his distinguished visitors, had not only indulged in the supreme luxury of a good 'clear-up', but like other good housekeepers he had followed the time-honoured custom of producing his very best 'chiney'. A large washhand-basin half-full of boiled rice graced the table. Inquiry elicited the fact that when alone and engrossed in painting the captain very seldom took the trouble to cook a proper meal, and on our departure five days before he had boiled himself this huge basin of rice, and ate his way steadily across as the pangs of hunger drove him from the easel. There was still about a quarter of a hundredweight of the cold stuff left in the dish, and the captain generously invited us to 'wire in'; but we laughed him to scorn. Cold watery rice! Not much. We had something infinitely better in hand."

They had promised themselves a "State banquet" to celebrate their return to "civilisation" and with commendable restraint they had carried a "Christmas plum pudding" with them all the way, saving it for their feast. With "tender solicitude" they heated the "delectable compound" in a billy hung over the open fire, then savoured each mouthful as it slid down. That night they stretched

themselves out "on real mattresses of dry straw, clad in the luxury of dry suits and lay back to listen to the patter-patter of the rain on the iron roof".

After waking to the usual breakfast call of "Roll up the battalion" they packed their bags and "filed down the corduroy staircase of the Clinton Chalet" to stow their baggage aboard Mackinnon's whaleboat, *Juliet*. "A fine roomy whaleboat built of cedar" it had been purchased for Mackinnon by Juliet Fulton, a daughter of the Hon. James Fulton of Dunedin, as a thanks for guiding her party over the track.

With a "full-sized gale howling" behind them they had a "rattling run" down the lake to Mackinnon's camp at Garden Point. During the voyage McHutcheson noted with considerable perception that the large steer-oar on the *Juliet* "taxed Mac's utmost strength to control and once at least almost sent him flying overboard". It was in the same whaleboat that Mackinnon perished the following year.

Mackinnon Missing

In 1892 Mackinnon was reported as missing. In a letter to C. W. Adams, Captain Melville Duncan of Te Anau wrote. "You will be sorry to hear that Quinton McKinnon [sic] left Te Anau for Milford on 30th November and hasn't been seen since putting in at Te Anau Downs. A search party under myself returned yesterday, having been out for 11 days and gone as far as Milford, without finding a trace of either McKinnon or his boat."

Mrs Melland now takes up the story providing us with some interesting new information. "The New Zealand Government had engaged him to put in three months at clearing the track a little of saplings and jungle. So he laid in a supply of provisions and called in his whale boat at our sheep station for some mutton and then set off up the lake with a fair wind. Nothing was heard of him for months so a search party of police constabulary sent by the government

Sir Thomas Mackenzie (right) and Captain "Tom" Roberts pay their respects at the stone monument carved by Richard Henry. *(G. Roberts)*

Mrs Katherine Melland of Te Anau Downs station who records the discovery of Mackinnon's sunken whaleboat near the station in 1892. *(Hocken Library)*

arrived at our homestead to hunt for Mackinnon. As one of our shepherds had picked up his cap on the shore of the lake one day, that part was searched first. We all joined in, either boating or on foot and Dick [Richard Henry of Te Anau] and Mr C. [C. W. Chamberlain, Commissioner of Crown Lands, Dunedin who was in the search party] soon found Mackinnon's whale boat [the *Juliet*] sunk in the bay of the lake, the tip of the mast just showing above water. His tucker box and sou'wester were picked up on the shore opposite, but his body has never been found."

Sir Thomas Mackenzie, a fellow explorer and friend of Mackinnon, who was also in the search party continues the story. "We gathered at the place, about half a chain off Lone Island, north of the mouth of the Eglinton River, and raised the boat. It lay in about 6 feet of water and had not capsized, as all Mackinnon's belongs were aboard, including a copy of the journal 'Black and White'. There was no sign of the explorer."

"It being our wish to mark the locality where Mackinnon's boat was found we selected a small islet about three chains away. On this islet a huge white

Left: The original wooden cross was still in place when Theodore King and William Craig (in foreground) visited it in 1904. *(T. King, courtesy Roy G. Craig)* Right: The replacement cross today. *(J. Hall-Jones)*

Below: Mackinnon's monument on Mackinnon Pass. Mt Hart on skyline. *(J. Hall-Jones)*

granite block had been deposited by a glacier years ago. Pillans attempted to cut Mackinnon's name on the stone but could not with the tools at our disposal and Dick Henry returned later to chisel out the name and date of the loss. Behind the block we placed a cross, building it with a cairn of stones, and hung on it a wreath of myrtle."

The cross was still there when Theodore King and William Craig of Gore visited the rock in 1904, but was gone a few years later when Sir Thomas Mackenzie returned to pay his respects. A new cross has been erected on the rocky islet in recent years. In 1912 a memorial cairn to Mackinnon was erected on the Mackinnon Pass by the New Zealand Gaelic Society and the Otago Rugby Football Union. Recently a statue of Mackinnon was erected on the Te Anau waterfront.

As to what happened to Mackinnon nobody really knows. But Mackenzie recalled having "a narrow escape with the explorer" in his boat opposite the entrance to the North Fiord and we have seen already how he was "almost sent flying overboard" by the steer oar on McHutcheson's trip down the lake. The fact that Mackinnon's boat was found uncapsized in shallow water suggests that this may have happened. With his seaboots on and perhaps knocked unconscious by the steer oar he wouldn't have stood a chance.

CHAPTER 5

Pioneer trekkers

Delighted with my trip as I am the first lady to have crossed from Te Anau to Milford.
Mrs Rosa Moreton, 7 February 1890

Eager to be the first to write up Mackinnon's overland route to Milford Sound, the *Otago Daily Times* reporter F. A. Joseph arrived by sea at Milford on 15 December 1888. He was "disappointed at not finding any trace of McKinnon's blazed trail on either side of the saddle, nor any guide marks on the saddle [itself. Otherwise he] found the saddle easy of ascent."

Hot on the heels of Joseph was Fred Muir who, because of the snowstorm, had been robbed of the chance to take the first photographs of the new pass. In January 1889 he made a very rapid crossing of the pass from Lake Te Anau to the Sutherland Falls in 16 hours. This time he was rewarded with superb views from the pass and he obtained his precious photographs.

January 1889 also saw Dr John Don (later headmaster of Waitaki Boys High School) with a party of Training College students following Mackinnon's blaze up the Clinton Valley and crossing the pass to arrive at Beech hut. They got as far as Lake Ada only to find that there was no boat there. Returning to Lake Te Anau they were marooned at the head of that lake for several days without food. Hungry eyes were cast at their dog, but happily for the poor beast a boat arrived and he was saved from the pot.

A studio photograph of this first Milford track party, taken after their arrival back in Dunedin, shows the expedition armed with guns and provides photographic evidence that their dog survived!

Another early trekker in January that year was Richard Henry of Te Anau, who later became famous as the "Caretaker of Resolution Island". Accompanied by Theodore King, the postmaster at Gore, the pair crossed the pass from Te Anau only to find, like Dr Don, that there was no boat on Lake Ada. Undeterred the ingenious Henry fashioned a boat out of a piece of corrugated iron that was lying around and they rowed down Lake Ada and across to Milford, before returning over the track. With typical modesty Henry left the visitors book unsigned.

The following January (1890) Dr Don accompanied by his brother William and guide Donald Ross walked the track again and this time the party got

Studio portrait of Dr J. R. Don's party of Training College students who walked the Milford track in January 1889. *Back left:* Dr J. R. Don, W. Montgomery. *Front left:* W. Maxwell, J. Montgomery, W. Burnside.

right through to Milford. Dr Don was obviously inspired by the Milford Track and an entry in the visitors book in 1905 shows that by then he had walked it ten times! "The view from McKinnon's Pass more magnificent than ever", he writes.

The resourceful Richard Henry who fashioned a boat out of a piece of corrugated iron to cross Lake Ada in 1889. *(Hocken Library)*

Samuel Moreton who accompanied his wife, twice, across the Milford track before Eleanor Adams walked it. Portrait by Elsie Boyd. *(Alexander Turnbull Library)*

On 14 January 1890 Samuel Moreton, who was helping the Sutherlands to build their chalet at Milford Sound, departed for Te Anau to pick up his wife and bring her back to Milford for a holiday. His entry in the visitors book is interesting as he writes quite pointedly that he was going "via Balloon Pass".

The First Woman to walk the Milford Track

On 7 February 1890 Samuel Moreton arrived back at Milford with his wife, Rosa, who wrote in the visitors book: "Delighted with my trip as I am the first lady to have crossed

Richard Henry's corrugated iron boat. *(E. Govan)*

from Te Anau to Milford". Her stay was all too short and on 9 March 1890, after writing in the visitors book "spent five very happy weeks here", the Moretons returned over the track to Te Anau. Rosa Moreton therefore traversed the track twice before Ella Adams, who used to be credited as being the first female to walk the track.

Eleanor ("Ella") Adams was a daughter of surveyor Charles Adams and on 29 March 1890 she set out from Milford with her father to traverse the track, which was still in the process of being surveyed and constructed. Although it was many years later that she wrote that she was "only eleven years old" at the time, it is interesting to find that her father entered her age in the visitors book as "aged fourteen". William Quill, who met her on the track, also records her age as fourteen. That is not to decry her journey over the rough unformed track, which even at the age of fourteen was still a remarkably good effort. In later life as Mrs Ella Spicer, the well known artist, she wrote a delightful account of her journey with her father. In those days they had to cross Lake Ada in a "little canvas boat".

"That little canvas boat was the only boat we had, and it held only two or three at a time, and it took some time getting the party over the river or lakes. Someone had to squat down in the bow and watch for any snags - Lake Ada was full of them - that might hole the

Right: Sketch of "Balloon Saddle" by Moreton in 1890, the year that he crossed the pass with his wife. Mt Hart on skyline. *(Alexander Turnbull Library)*

canvas. We had a very rough walk from the Sound to the Ball (now called Quintin) huts, and it took a long time getting us up Lake Ada in the canvas boat – I think some of the party scrambled round the Lake. It was lucky there were the two huts near the Sutherland Falls, for we had to stay many days there on account of bad weather. The huts were very primitive affairs, but they, as well as Sutherland's hut, all had some very pretty curtains, and I wondered where the material came from. One of the surveyors told me [or perhaps spun her a yarn] that it had been torn from a French countess's dress, when she had tried to walk up from Milford to see the Falls; she had returned to the tourist ship with only the lining of her dress left, and no shoes.

One day while we were at the Ball huts we had a frightening thunderstorm – in the flashes of lightning the mountains seemed to tower over us.

At the Ball huts the bush rats were dreadful, but luckily I was not afraid of mice and rats, but all the same did not like them running all over me as soon as the lights were out. I begged a yard of the white calico – used for the survey pegs – from my Father, and cut a good many holes in it so that I could breathe, and put it right over my head. I felt quite happy that way. During this bad weather my Father was very anxious, and wondered when we could get over the Pass.

One day we saw the Sutherland Falls – we were about a quarter of a mile away I think, but we were covered with spray. I lost all sense of distance among those huge mountains, and thought I could throw a stone into the pool at the foot of the Falls.

At last a good day came, and the party for Te Anau and ourselves started off over the Pass. It was hard work pulling ourselves up through the heavy bush, but above the bush line the way looked very dangerous, especially skirting Mt Balloon, where the rocky ground was all slimy with moss and water. Quintin McKinnon roped me to himself, and my Father and I all got safely to the top of the Pass. The little tarn on top of the Pass was called after me – Lake Ella. Looking down the thousands of feet into the valley we had left was awe-inspiring. The only way I could look was to lie down flat and pull myself to the edge of the cliff, and get my Father to hold my ankles!

We camped somewhere near the foot of the Pass [at Lake Mintaro], and all night were kept awake with avalanches falling. Just over the Pass among the heavy bush we went through acres of the large flowered hohere or ribbonwood – it was like a cherry orchard in Spring.

Going down the Clinton Valley was the easiest part of the journey, and very lovely. When we came to the Clinton River it was a raging torrent with huge boulders, and the youngest of the Quill brothers [John who was working under Mr Morgan upgrading the Clinton side of the track] carried me across. We could see the river coming out from a huge ice cave at the head of the valley, and also saw an avalanche falling near.

The track to Te Anau was fairly level, and we caught glimpses of the Clinton River with its clear greenish waters. The native birds were so tame, and the little robins would come and perch on our toes and hats while we had our meals, ready for any crumbs. And nearly always while my Father was surveying, a robin would perch on his hat or theodolite. Wood hens were plentiful in the Clinton Valley, and would run off with anything bright they could find in your tent. If you imitated their call they would come right up to you. I think it took us three weeks to reach Lake Te Anau, and then we had three days in McKinnon's boat on a perfectly calm lake rowing all the way, and camping two nights on lovely little beaches.

An early photograph of Lake Ella showing walker on the original track around the far side of the lake. Jervois Glacier in background. Mt Balloon on right. *(F. Muir, 1908)*

Boat party from a cruise ship on its way to the start of the Milford track. Donald Sutherland with boat pole. *(Hocken Library)*

Below: Excursion party from *s.s. Tarawera* being landed at the start of the track, February 1891. Steam pinnace anchored in Arthur River. *(Hocken Library)*

McKinnon shot some duck, and cooked our dinners over a fire in a kerosene tin in the boat. We stayed at a sheep station [Melland's] on the east side of the lake for the night, and next day we rode our horses back to Lumsden where we got a train to Dunedin."

Trips to the Falls

For the not so hardy there was a much easier way of seeing the Sutherland Falls, by taking an overnight trip to Beech huts from a steamer calling at Milford. Charles Adams in 1892 describes such an excursion from the ss *Tarawera* which used to call at Milford Sound three times a season and offer this trip.

"As we steam up the narrow passage the gun is fired, partly to apprise those at the head of the sound that we are coming and partly to give the passengers an opportunity of hearing the long series of reverberations [off the cliffs] that follow the report of the explosions:

Crag calls to crag, the giant peaks reply,
The chorus swells, and then the echoes die!

The sailors moor the ship to the red buoy at the head of the harbour and a boat puts

off from Sutherland's little jetty to welcome us. The steam launch is quickly crowded with the large number of passengers who have decided to make the excursion to the great Sutherland Waterfall. A run of two miles brings the launch to the lower landing place [Sandfly Point], where all are quickly disembarked and the tourists put themselves in marching order, each one carrying what is called a 'swag', as both provisions and blankets have to be carried.

The two guides who generally conduct these expeditions to the Sutherland Falls are Donald Sutherland, who discovered the Falls and also cleared the track leading to them, and Q. McKinnon who discovered the overland route from Te Anau. Two better men could not be found, as they are both thorough bushmen in every sense of the word.

The track from the landing lies on the left bank of the Arthur River with pretty peeps [of the river] on the way. At Lake Ada a hut [Doughboy hut] has been erected at the end of the track. It is about 11 by 13 feet with a door at one end and chimney at the other, and contains eight bunks or berths.

But 'all-aboard' is now the cry and the tourists carry their swags to a seat in one of the boats. Volunteers now man the oars and soon the three boats are on their way up the lake. When opposite 'Giant's Gate' [Falls] a halt is made to admire the beautiful scenery. Then the rowers bend their backs [again], the boats speed onward and the head of the lake is soon reached. The [Arthur] River is entered and after a while the current becomes very perceptible. 1½ miles after leaving the lake the upper landing is reached and now the real work of the day begins. Each one, old and young, male or female, has to walk 5½ miles along a rough track before the Beech huts are reached. Questions become frequent as to 'How much further to Beech huts?' and 'When shall we see the Falls?' Presently a cry is heard from the guide 'First view of the Falls!' We all press forward but only the top of the Fall is visible. Some go into raptures, while some of the tired ones express disappointment. But again the guide calls out 'Forward!' and encourages the weary ones by telling them that the Beech huts are only ½ mile further on.

We all put on a spurt and in due time arrive at the two 'Beech huts', so called because they are in beech forest and are built of beech trees. They are [in 1892] quite inadequate for the increasing stream of tourists. The bedding and provisions that have been carried so far are deposited in the huts, as this is where the night is to be spent. After a short rest the tourists start off with light hearts on the track to the Falls. It is not till the traveller emerges [from the last of the forest] and stands on a small rocky eminence in the open that he gets a full view of the foot of the Fall and the dark pool into which it descends. And standing there in the roar of the falling waters what language can portray the magnificence of the scene?

But now the sun has set behind the amphitheatre of mountains to the west of the Fall and we must be going. Reluctantly we retrace our steps feeling a sad presentiment that we shall never visit this spot again."

Above: The original log bridge across Roaring Burn to Beech (Quintin) huts, 1897. *(R. Haweridge)*

Left: The only known picture of the original beech-slab huts at Quintin. Both were replaced by corrugated iron huts in 1897.

Right: An early photograph of the Sutherland Falls in "full roar". *(F. Muir)*

CHAPTER 6

The Milford track develops

The 40 thieves left for Wellington. A good thing for the Country that they have cleared out of this sound. Have no wish to see them again.
Donald Sutherland, 27 August 1892

With more and more people using the track there was a growing demand to upgrade it. The government reacted positively and at one stage even began to construct a coach road to the Sutherland Falls. Assistance for the latter came from an unexpected quarter.

Humeville

Lieutenant Colonel Alexander Hume, the Inspector General of Prisons, had worked in Great Britain where he had been impressed by the experiment of setting carefully selected prisoners to work in sparsely populated areas. On 14 December 1890 he arrived at Milford in the government steamer *Hinemoa* with 45 prisoners and six officers to establish "Humeville Prison" at Sandfly Point. The prison camp would serve as a base "to cut the Te Anau road", he wrote optimistically in Sutherland's visitors book.

The prison barracks were erected on the flat that is now bridged by a causeway to the present Sandfly huts. With three corrugated iron huts for the prisoners, staff quarters, a cookshop and storeroom "Humeville" was a compact little settlement, but today very little remains.

Within days of their arrival two of the prisoners escaped and fled over the Milford Track to jump the lake

Alexander Hume, Inspector General of Prisons, who accompanied the prisoners to Milford in 1890.

The government steamer *Hinemoa* which brought the prison gang to Milford in 1890 and removed "the forty thieves" two years later. *(Alexander Turnbull Library)*

steamer, *Te Uira*. They must have been congratulating themselves on a clean getaway as they were taken down the lake on the *Te Uira*, but when they arrived at Te Anau the police were waiting for them on the wharf. The following year two more prisoners escaped, this time getting as far as Mossburn before they were recaptured.

On 6 November 1891 one of the prisoners, Michael French, an Irish-born

Price's gang camped at Boatshed hut, 1893. Price standing bareheaded on right. *(C. Kerr)*

Right: William Rathburn's grave at Cemetery Point. *(J. Hall-Jones)*

instead. Also that "Hume Road" be reduced in width to a pack track.

On 24 August 1892 the *Hinemoa* departed for Wellington with "the 40 thieves", as Sutherland called them in his visitors book. "A good thing for the country that they have cleared out of this sound. Have no wish to see them again."

Price's Gang

Work continued on the track with more reliable sources of labour, such as Edwin Price's gang which did much of the difficult rock-blasting around Lake Ada and round the huge rock bluff at the present Arthur River swingbridge. Most of Price's gang were ex-miners, competent with explosives,

labourer, died after being sick for some time. Although the prison doctor performed a postmortem and diagnosed the death as being due to "disease of the kidney", it should be noted that French was seen fighting with a fellow prisoner shortly before he died. It could well be that some injury had contributed to his death. The head gaoler, Robert Conyers, selected a site for the grave on the opposite side of the river from the prison and French was buried with a picket fence around the grave. The picket fence was still there in the 1920s but was gone when Mr Gill of Invercargill saw the grave in 1931. In the 1950s William Anderson found a solitary rotting peg at the site.

In 1892 "Humeville" was visited by the Minister of Labour, Dick Seddon (later the Prime Minister). By then discipline had become extremely slack and the prisoners were working on only dry days, which was less than half the time in this area. With only two kilometres of the road to Doughboy completed, Seddon could see that the experiment had been an expensive failure. He recommended that the prisoners be withdrawn and replaced by contract labour

Price's gang rock-blasting the track round the bluff on the Arthur River near the present swingbridge. Edwin Price wearing bowler hat, far left. *(E. Govan)*

The rock-blasted track above Lake Ada. The names of two of Price's gang, Stenhouse and Mahon, are carved at eye-level to the immediate left. *(J. Hall-Jones)*

and it may have been more than a coincidence that nearly all came from Kumara, Seddon's hometown on the West Coast.

One of Price's gang, Harry Gilmore, tells us that they were paid one shilling and threepence an hour and were happy to work for a ten hour day.

Their camp was on the Arthur River, "a couple of miles above Lake Ada", where they were visited by "occasional tourists" and guide Donald Ross "who passed to and fro". Writing in 1893 Ross recorded the camp as being at the Poseidon hut (the original name for Boatshed hut). "There were 13 men plus a cook at

the camp" noted Ross, "mainly from the West Coast".

When one of the gang died in 1892 Gilmore and a mate took off over the Mackinnon Pass on a nightmare journey to get a message out to Te Anau. In 1894 another trackman, William Rathbun, a Canadian died at the age of 64 and was buried at Cemetery Point at Milford, where his grave can be seen at the foot of the Bowen Falls.

A photograph in 1893 shows Edwin Price, clad in bowler hat and suit and his gang in waistcoats, rock-blasting round the great rock bluff near the east end of the present Arthur River swingbridge. Today the remains of the old rock-carved track can be seen clearly as you mount the swingbridge at its eastern end.

The difficult rock-blasting on the bluff above Lake Ada was not completed until 1898. The names of two of the gang, "Stenhouse and Mahon, Kumara, 1898", can be spotted at eye level on the rock wall just a few metres short of the crest of the rock-carved track.

Quill climbs the Falls

Working for Adams on the track was a young surveyor William Quill from Kuri Bush, Taeri Mouth. Quill had arrived at Milford on the *Hinemoa* on 15 October 1889 and had met Donald Sutherland whom he found "very amusing" and also "very entertaining on his musical box". Moving over to the track Quill, with "Ted" Wilkins and "Bill" Coutts, built

Surveyor William Quill who climbed the Sutherland Falls three times in 1890. (S. Quill)

Right: Sutherland Falls and Lake Quill. (R. Crone)

Doughboy hut and then shifted up to Poseidon hut (Boatshed hut) and on to Slip camp to continue the track up to Beech huts. (Visiting Poseidon hut in 1889 Bella Hislop describes it as being "built of birch [beech] logs split in two, the floor being laid in same".)

As Sundays came around the energetic Quill would look for something to do and he set his mind on climbing the Sutherland Falls. On Sunday 5 January 1890, accompanied by Ted Wilkins, he climbed to the top of the second leap and planted a flag there. Then on Sunday 9 March he set out alone for the top.

"After breakfast I left Beech Hut in my usual climbing costume, taking also a billhook, a rope and a piece of calico – on which was painted my name and date. I began the climb about three or four chains to the east [true right] of the lower fall, reaching the top without too much difficulty. But beyond this face is smooth granite rock and one has to be careful. Because of the spray coming down I kept away from the fall but about 700-800 feet up I encountered a thick growth of a nasty kind of scrub, which with the increasing steepness made my progress exceedingly slow. I had to creep as best I could through this stunted scrub to the base of the upper leap – where there is a remarkably level area with grass and shingle, not unlike the foot of the lower leap.

"But now commenced the real climb. A steady hand and a strong nerve were all that kept me from slipping, where the least slip would send me down the perpendicular rock to be dashed to pieces hundreds of feet below. As I was nearing the top I had to work to the left [true right] to avoid a high precipice and at last, after three-and-a half hours hard climbing, I came out on the brow of the cliff. I travelled down this brow and now I stood on the summit of the highest

The chasm at the outlet of Lake Quill which Quill leapt across on his second ascent.
(R. Willett)

Footprints on Gertrude Saddle where, in 1891, Quill fell into the Gulliver Valley far below.
(J. Hall-Jones)

[sic] waterfall in the world.

"As I stood I turned towards the south and discovered a beautiful lake about a mile wide [later named Lake Quill], fed by the immense glacier on Mt Sutherland. [Interestingly Quill is using the original name for Mt Mackenzie.] This lake is the reservoir of the Sutherland Fall. The outlet is a deep chasm about 100 yards in length. The water rushes through this chasm with great force and swiftness, making a terrible noise – and about 10 yards from the lower end strikes a face of rock to make a pretty curved leap in the air (somewhat after the manner of the Bowen Falls, but on a smaller scale) to disappear over the edge of the cliff.

"As near to the top of the fall as there was holding ground, I erected my calico flag – which can be seen from below. I returned to the base of the falls in two-and-a-half hours without a scratch or bruise."

As if one ascent was not enough the intrepid Quill returned the following Sunday (16 March 1890) to climb the falls again and take some barometric readings. Adams lent Quill his barometer for the day and the young surveyor carefully recorded the readings and temperatures at various levels in his diary. On this occasion he leaped over the chasm at the top of the falls and planted a flag on the far side. He then went on to climb Mt Sutherland (Mackenzie),

returning down the falls in 1½ hours.

Further research of Quill's diary shows that he climbed the falls yet a third time – this time accompanied by Bill Coutts. "Sunday 4th May, 1890", writes Quill, "I and Coutts went to the head of the falls, doing the feat of returning home by Mt Hart. Splendid view all round and we had the pleasure of seeing old briny." Later in his diary he describes the Sutherland Falls as "something grand. When in its descent it strikes New Zealand its noise resembles thunder or artillery." [Quill's climb was not repeated until 1950 when Gordon Craig ascended the falls.]

But poor Quill's days were numbered. In January the following year he set out from Queenstown in an attempt to discover a route through to Milford via the Hollyford Valley. On 13 January he reached the foot of the Homer Saddle but the fog closed in so he tried the Gertrude Saddle instead, "but could only get a little higher than the lake" (Black Lake). Thoroughly frustrated he took a pot shot at two keas with a shanghai, killing both and skinning them to eat.

On 14 January he returned to Homer Saddle, this time climbing it successfully to mount a flag on a cairn, which he hoped could be spotted from the Cleddau Valley below. Once again the fog closed in and he could proceed no further.

Then on 15 January 1891 he set out to climb the Gertrude Saddle to look for a route that way, but he never returned. When he failed to turn up Thomas Quill, one of the younger brothers who had worked with him on the Milford Track, set out to look for him. He soon found his brother's diary, with its last poignant entry:

15 Jan. 1891 Foggy but wind changed to SW – sign of a fine day. Going up to Lake Gertrude Saddle as soon as looks better. Will have a look for Cleddau [Valley] by that way.

Now joined by his other brother, John, the two followed William's footsteps in the snow on the Gertrude Saddle until they came to the edge of a precipice, "where he appeared to have dug his heels in firmly so as to obtain a better view down the valley; but the soft peaty soil had yielded and he had slipped over the edge."

Despondently, the two brothers set off for Invercargill and sailed round to Milford to search the far side of the saddle. Reaching the foot of the saddle they followed a little watercourse up for about 600 metres to find a few shattered remains of their brother's body. Having proved that their brother had been dashed to pieces in falling over the terrible cliffs, Thomas Quill returned to the family home at Taieri Mouth to break the sad news. Altogether the two brothers had spent six weeks, often short of food, searching for their brother. He was only 25 years old at the time of his death.

In 1910 W. G. Grave and A. Talbot while pioneering the Grave-Talbot Pass

Plaque to William Quill mounted on boulder (at waist level of man standing) at foot of the Gertrude Saddle. *(D. B. Dallas)*

through to Milford came across the cairn erected by Quill on the Homer Saddle, the day before he lost his life on the Gertrude Saddle. In 1932 D. B. Dallas of the Public Works Department, Milford, on behalf of the Quill family, mounted a bronze memorial plaque to William Quill on a large boulder at the foot of the Gertrude Saddle on the Milford side. Unfortunately this area is notorious for avalanches which sweep down into the valley each year and when two members of the family, Air Commodore Stanley Quill of Wellington and Pat Quill of Invercargill, searched the head of the valley in 1975 they found that the plaque had disappeared.

One of the finest tributes to Quill was written by his boss, Charles Adams, ten days before he perished. *"His energy and force of character is so great that no matter how difficult or arduous the task he will either find a way or make one."*

Close up view of the inscription on the plaque. *(D. B. Dallas)*

CHAPTER 7

Glade House

I would like to build a house in this glade.
Louisa Garvey, 1895

When John and Louisa Garvey of the Marakura Hotel, Te Anau, landed at the head of Lake Te Anau in 1895 and walked up the east bank of the Clinton River they came to a beautiful clearing in the bush. It was an idyllic spot, the grass growing right down to the river's edge, the crystal clear Clinton gliding gently by, a magnificent backdrop of rugged bushclad mountains. "I would like to build a house in this glade", said Louisa to her husband. Louisa's wish was fulfilled when "Edward Melland and some friends interested in the beauties of the track lent the Garveys money to erect an accommodation house at the head of the lake", writes Katherine Melland. "Tourists could then have a comfortable bed after a long day [on the *Te Uira*] on Lake Te Anau and before the walk proper began. Tourists were rather a nuisance to us, coming sometimes in parties, all men of course, sometimes with horses too, and calmly asking us or our manager to take them in. Of course we had to, there was nowhere else for them to go."

Thanks to the financial backing of the Mellands, Angus MacBean was engaged in August 1895 to build the first Glade House in the beautiful open glade on the east bank of the Clinton River, about a kilometre upriver from the lake. Built with a framework outside to keep the rats out, it had a long rustic verandah which Louisa covered with climbing roses. Louisa's dream house was completed and ready in time for the 1895-96 track season.

One of the Garveys' earliest guests was "Mac", a contributor to the *Southland Times*, whose party was stranded at the head of the lake in 1896 after walking the track. The *Te Uira* had departed a day earlier than scheduled, a not uncommon happening. Typically the Garveys rose to the occasion and looked after the unbooked guests for a whole week

John and Louisa Garvey who established Glade House in 1895. *(Y. Dore)*

Edward Melland of Te Anau Downs station who financially backed the building of Glade House. *(Hocken Library)*

Left: The original Glade House in 1903. Louise Garvey on left. Dore Pass on skyline extreme right. *(Hocken Library)*

The McGeorge party at Glade House, 1901. Note sandfly veils on hats. *(M. McGeorge)*

before the *Te Uira* returned to pick them up.

With a family of eleven children the Garveys quickly established a reputation of homely hospitality with evening entertainment, a tradition that has been maintained to this very day. Six of the Garveys' eldest sons served as guides and trackmen on the Milford Track and their second youngest boy, Charley, walked the entire track at the tender age of eight! (See entry Sutherland's visitors book, 29 March 1900.)

Prior to the opening of Glade House John Garvey inspected the track and he leaves us an interesting description of the huts in the Clinton Valley as they were in 1894. The Clinton hut, which had been built by the government in 1890, was "a two-roomed building of convenient size" where the tourists spent the night after voyaging up the lake with Captain Brodrick in the *Te Uira*. McHutcheson's party, as we have seen, stayed at the hut before and after their walk in 1891.

Mid hut, or Halfway hut as it was sometimes called because it was halfway up the Clinton Valley, was "used as a lunch spot and an emergency shelter". Built by Donald Ross and "three bushmen" in 1894 it was a fine slab hut with "two substantial rooms" and an enormous slab chimney. Mid hut stood in the little clearing at the seven mile peg, on the far side of today's big slip. It was later replaced by a corrugated iron hut which was still in use when the author passed this way in 1972, but nowadays only a few rusting relics remain.

Pompalona was just "a tent to rest in" when Garvey and later "Mac" passed through. The first hut at Pompalona was not built until as late as 1906. Lake Mintaro hut, which was built in 1893 by Samuel Stevens, therefore preceded Pompalona hut by a whole 13 years. John Garvey describes Mintaro hut as "a commodious structure of goodly proportions, furnished with bunks and necessary agenda to enhance the comfort of the tourists. There is also a

Mid hut, which was built of slab timber by Donald Ross in 1894. The McGeorge party outside in 1901. *(M. McGeorge)*

The later corrugated iron Mid hut with packhorses outside. *(C. Kerr)*

The original Mintaro hut, which was built in 1893 by Samuel Stevens. *(A. S. Sutton-Turner)*

The original Mintaro hut, photographed in 1914 by Edgar Williams and labelled "the old Mintaro hut". Note packhorse. *(E. Williams)*

GLADE HOUSE

Right: Donald Ross (in foreground) guiding a party over the Mackinnon Pass. *(Hocken Library)*

Below right: The *Tawera* berthed at Glade House wharf in 1915. Note tall funnel. *(Hocken Library)*

separate compartment for ladies." Mintaro hut was sited inside the right-angled bend of the turnoff to the present day Mintaro hut. Some slab timber, old corrugated iron and concrete foundations can be found there.

After the opening of Glade House, the Clinton hut fell into disuse and the start of the Milford Track was re-routed along the Glade House side of the river. From Glade House walkers were ferried across the Clinton River to link up with Mackinnon's original track in the vicinity of Mackinnon's hut. "Mac's" party came this way and they saw Mackinnon's hut still standing on its wooden piles, a sad "reminder of the lonely explorer". At Mackinnon's hut they met Donald Ross, "the popular government guide" who with his brother, Jack, succeeded Mackinnon as guides on the Milford Track.

In 1903 the Tourist Department purchased Glade House as part of its general take over of the Milford Track, but the Garveys were retained as managers and stayed on right up to 1908. In 1906 Metcalf and Morris carried

The extended Glade House in 1906 showing the two new wings added on. The boat is ferrying track walkers across the Clinton River in the days before the swingbridge. *(Y. Dore)*

MILFORD SOUND

out extensions of Glade House, building new accommodation wings at each end. At the same time the department also appointed Robert Murrell of Manapouri as chief guide on the track and walkers were issued with track tickets costing the princely sum of three shillings and sixpence (35 cents) per person.

Glade House was linked to Milford by telephone, but communication with the foot of the lake was maintained by carrier pigeon which kept the Garveys informed as to how many tourists to expect. The telephone line was fine when it was working but it was highly susceptible to damage by windfalls and avalanches and was in a continual state of disrepair. Pigeon lofts were built at the huts along the track and pigeon post proved to be the surest means of communication.

In 1906 the track's first two packhorses were transported to the head of the lake on the foredeck of the *Tawera* where temporary stalls were set up. There was excellent grazing at Glade House and holding paddocks were established at Pompalona and the other huts. Stores could now be carried to the huts by packhorse, sledge or cart as well as manpower.

Glade House razed to the Ground

The fire started just after midday on New Year's Day 1929. It began in the boiler room, but quickly raced through the whole wooden building with flames leaping out of the windows and through the roof. A large party from the Otago Tramping Club had just arrived back from Milford and in the absence of any fire fighting equipment a 'bucket brigade' was organised. But the task was a hopeless one and the trampers turned their attention to saving as much as they could from inside. With the whole building engulfed in flames Glade House was razed to the ground. The timing of the fire at the height of the tourist season couldn't have been worse. But temporary marquees and tents were set up until a new Glade House was built in 1930.

Birley and Dore Passes

In 1907 guide Harry Birley of Glenorchy, the conqueror of Mt Earnslaw, surveyor Murcott, Sir Thomas Mackenzie and three of his sons, set out on an "exploratory trip" from near the head of Lake Te Anau in search of a route through to the Eglinton Valley. Landing at the mouth of Nurse Creek they followed the creek up to a pass, which became known as "Harry Birley's Pass" and down the Murcott Burn on the far side to its junction with the Eglinton River. Continuing up the Eglinton Valley they reached the Lake Howden camp from where the party completed their journey to Lake Wakatipu via the Greenstone Valley.

After the trip Mackenzie asked Birley to see if he could find an alternative

Glade House on fire, New Year's Day 1929. Members of Otago Tramping Club carrying water buckets. *(H. Mills, Courtesy L. and L. Galloway)*

Below: Glade House razed to the ground. *(H. Mills, Courtesy L. and L. Galloway)*

Sir Thomas Mackenzie (with bowtie) with his family at Glade House in 1908. Mt Mackenzie (named after him) in background. *(Hocken Library)*

Left: The McGeorge party on "Harry Birley's Pass" in 1910. Note tall wooden guide pole on pass. *(M. McGeorge)*

higher route to Lake Wakatipu via the Harris Saddle and Routeburn Valley. Carrying out his orders Harry Birley pioneered a suitable route via Lake Mackenzie in 1909. And so it happened that beautiful Lake Mackenzie on the Routeburn track was named after the politician although he didn't actually go that way.

One of the earliest parties to use "Harry Birley's route" was a large group including Joseph and Alex McGeorge, the Digby Smith sisters and Mr and Mrs Samuel Crow, who in February 1910 set out from Lake Howden camp with guides Donald and Jack Ross. Thanks to Samuel Crow we have excellent

The camp at Lake Howden which preceded the hut. *(Southland Museum)*

Murcott Burn hut in 1921. Note high piles to avoid flooding. Framework of original camp behind. *(Otago Witness)*

The original Murcott Burn camp in 1910. The Digby-Smith sisters outside. *(M. McGeorge)*

photographs of the original Lake Howden camp before the hut was built, the Murcott Burn camp at the junction of the Burn with the Eglinton River and the party on the top of "Harry Birley's Pass".

But the trouble with "Harry Birley's route" was that it finished in the "middle of nowhere" at the edge of Lake Te Anau and trampers had to arrange to be picked up by boat. In 1910 when J. B. C. Dore of Manapouri was appointed chief guide on the Milford Track he determined to seek a better alternative access to Glade House than the Birley Pass, which was also subject to heavy windfalls in the Murcott Burn Valley. He had spotted what looked like a promising pass at the back of Glade House, but what was it like on the far side?

In March 1911 Dore and Joe Beaglehole ascended Skelmorlie Peak from the mouth of Nurse Creek and looked down on the Murcott Burn Valley to discover that it branched into two, the right leading up to Birley Pass and the left to the pass behind Glade House. Then on 12 April 1911 Dore with trackhands Jack McGavock and Frank Dysaski climbed up on to the pass behind Glade House and dropped down the Murcott Burn Valley to the camp at the Eglinton

Skelmorlie Peak which J. B. C. Dore ascended from this bay at the mouth of Nurse Creek in 1911 to discover the Dore Pass (on the far side). Birley Pass is out of view to the right. *(J. Hall-Jones)*

Dore Pass from the Eglinton Valley side with the discoverer, J. B. C. Dore, seated in the foreground. *(Y. Dore)*

J. B. C. Dore who discovered the Dore Pass in 1911. *(H. Dore)*

junction in five hours walking time. The following day they returned to Glade House via Birley Pass taking seven hours and finding it much rougher going.

Dore sent a report to the department that he had found a much easier and more direct route to Glade House and shortly afterwards he received word that the pass was to be named after him. The pass offered a fine view of the head of the lake, Glade House and the whole length of the Milford Track up the Clinton Valley.

Dore kept a bicycle at Murcott Burn camp and if he wanted to get home to Manapouri he used to climb over his pass, jump on his bicycle, pedal along the sheep tracks to Te Anau Downs and hitch a lift down the lake on the station's boat.

The discovery of Dore Pass provided an attractive alternative access to the Milford Track for the more adventurous tramper, with the bonus of that superb view from the pass on the way. From the Lake Howden hut at the head

of the Greenstone Valley the tramper either descended into the upper Eglinton Valley where there was a blazed trail around the lakes, or kept high on the open ridge tops of Key Summit and descended by a long steep slip to Lake Gunn. Then across the Eglinton River at Cascade Creek to follow the river bank down to the Murcott Burn camp and so up the Murcott Burn Valley to Dore Pass.

Tragedy on the Dore Pass

In November 1936 Hugh Crawford, the only son of Dr Ritchie Crawford of Invercargill, and John de Lambert, a young engineer working on the Milford Road, set out on a tramping expedition over the Dore Pass. Leaving their car at Cascade Creek they crossed the pass to Glade House and spent a week in the Milford Track area.

On 13 November they started out from Glade House to recross Dore Pass but somewhere near the summit Crawford missed his foothold and slipped over a steep face. De Lambert managed to work his way down the steep rocky face only to find his companion deeply unconscious from a severe head injury. He also had a broken arm. After staying with him for two hours without any sign of recovery De Lambert realised that he could do nothing more without assistance. By now it was snowing heavily and bitterly cold. Making Crawford as comfortable as possible De Lambert set off on an arduous journey down the snow-swept track to Glade House. On his arrival there a rescue party was quickly organised and led by De Lambert, who although cold and tired insisted on returning, set off up the track only to find that Crawford had meantime succumbed to his severe head injuries. He was only 24 at the time.

The body was recovered the next day by Constable Thompson of Lumsden and six volunteers from the Public Works camp at Te Anau.

Dore Pass (on right) from the Murcott Burn Valley. *(P. Wallace)*

CHAPTER 8

The finest walk in the world

The foot-road is good through the shady bush and the track over the Pass is a well-graded alpine path.
J. Cowan, 1906

In March 1908 Miss Blanche Baughan of Banks Peninsula walked the Milford Track and wrote an article entitled "A Fine Walk" for the *Spectator* magazine in London. It obviously appealed to the editor, J. Strachey, who doubtless with an eye to sales, 'beefed up' the title to "The Finest Walk in the World" and published it in a 1908 issue of the magazine. Afterwards Whitcombe & Tombs NZ, with permission of the *Spectator* republished the article in the form of an attractive booklet, adding some professional photographs by Muir & Moodie and the Government Tourist Department. The booklet proved a winner, selling out within two months and requiring a reprint.

Thus by the sales whim of an editor in Great Britain who had never been to New Zealand, let alone seen the Milford Track, the track became known as "The Finest Walk in the World". There are of course many other fine walks in the world, including the Routeburn and Kepler tracks in Fiordland. Nevertheless the title lives on.

Publicity for the Milford Track also came from the pen of the well known author James Cowan, who wrote an account of his walk in 1906 in the Tourist Department's own publication *New Zealand Lakes and Fiords* (1906). "The foot-road is good", he wrote, "through the shady bush, and the track over the Pass is a well-graded alpine path. There are comfortable huts with dining rooms and accommodation at Glade House, and at Pompalona and Quintin (on either side of the Pass) with resident cooks at each."

Cowan's listing of the Pompalona hut in 1906 (spelt correctly with an 'a') is interesting as this is the earliest mention of the new Pompalona hut, which was built that same year and which replaced the old Mintaro hut as the accommodation hut on the Te Anau side of the pass. Mintaro hut was retained as a 'tea break' hut prior to crossing the pass.

Cowan's use of the name Quintin huts for the old Beech huts is also interesting. As early as 1892 Charles Adams reported the Beech slab huts as being "quite inadequate". Four years later in 1896 "Mac" wrote that "a new hut is required". In the same year guide Donald Ross reported that "the Beech huts

The original Pompalona hut, which was built in 1906. Wife of the manager in doorway. *(F. Muir, 1908)*

are falling into decay". But it was not until 1899 that "two [corrugated] iron huts were erected there, each with sleeping accommodation for 18 people", one for males and the other for females.

"The Quintin huts", writes Cowan, "are a welcome sight to the tired traveller after crossing the pass". Describing the huts as "standing in a little clearing in the midst of dense beech forest", he provides the earliest known photograph of the corrugated iron Quintin huts. All other photographs of the huts show the additions which were subsequently built on.

Like McHutcheson, Cowan was equally impressed by the great avenue of beech trees that lined the track from the huts to the Sutherland Falls. "This

E. Lee MP for Oamaru (extreme right) and Mrs Lee (at door with sandfly veil hat) at Pompalona hut c.1908. Possibly guide Donald Ross in centre with watch chain. *(Hocken Library)*

is one of the loveliest of woodland walks", he writes. Visiting the falls Cowan was captivated by their appearance in the same way as Adams. "The more you gaze at them the more your wonder grows."

Continuing down the valley of the Arthur River, "the river is crossed by means of a cage running on a wire rope, or by boat", records Cowan. In 1909 the Arthur River cage was replaced by a light suspension bridge, about 300 metres above Boatshed hut. Unfortunately this original bridge was "badly damaged" in a flood in the year that it was built, "the piers being canted so that the water reached the decking". A replacement bridge with high wooden towers at each end was constructed in 1910, but in time the wooden towers rotted away and the Arthur River crossing reverted to a boat service until the present wire swingbridge was built downriver from Boatshed hut in 1970.

After visiting the McKay Falls with its impressive Bell Rock, Cowan continued to Lake Ada "where travellers are given the option of rowing four

Trackmen's huts at Pompalona, 1911. On extreme left, Joe Beaglehole who accompanied J. R. Dennistoun on the first ascent of Mitre Peak. On extreme right, Jack Lippe who later supervised the students working on the Grave-Talbot track. *(Y. Dore)*

The earliest known photograph of the corrugated iron Beech huts (Quintin huts), 1906. *(J. Cowan, 1906)*

This photograph in 1908 shows how one of the huts has been replaced. *(F. Muir, 1908)*

Cage that preceded the Arthur River swingbridge. *(Hocken Library)*

miles down Lake Ada" or carrying on around the lake, the latter having the advantage of seeing the magnificent Giant Gate Falls. From Doughboy at the foot of the lake, there is an "excellent road [Hume Road] along the bank of the rapid-whitened" Arthur River to Sandfly Point where there is "an iron hut" connected with Sutherland's accommodation house. "In answer to the telephone ring the Milford pioneer's launch will shortly be seen rounding the point and soon afterwards the traveller will find himself enjoying a good dinner in a surprisingly cosy little home."

After the death of Donald Sutherland in 1919 Elizabeth Sutherland could cope with only a limited number of people in her Chalet. The "iron hut" at Sandfly Lodge was therefore replaced in 1920 with a fully staffed lodge, with Mr and Mrs Adams in charge. Unfortunately Sandfly Lodge was totally

MILFORD SOUND

assistance of Army engineers, including soldiers from the Fijian Army.

Moir also records that C. Barwell of Auckland rode a bicycle over the Mackinnon Pass in 1925, a feat that would not be encouraged today!

By 1925 the old track to the original suspension bridge across the Arthur River had become disused and "by using the telephone at the two iron sheds [Boatshed hut, which is still standing] Sandfly huts can be communicated with to enquire about the next boat on Lake Ada". Otherwise those carrying on by foot were ferried across the Arthur River by boat until 1970, when the wire swingbridge was slung across the river about a kilometre below Boatshed hut.

The first shelter hut on

This second bridge across the Arthur River was built in 1910 about 300 metres above Boatshed hut. Note high wooden tower with telephone line attached to far side. *(Y. Dore)*

Righ: Boatshed hut today showing boatshed doors still in place, boat launching ramp and winch (on right). *(J. Hall-Jones)*

destroyed by a disastrous fire in 1926, but tent accommodation was offered to walkers until the opening of the brand new Milford Hotel in December 1928. The remains of the brick chimney of the old Sandfly Lodge can be seen at the back of the present shelter huts at Sandfly Point.

Describing the Milford Track in 1925 in his original edition of *Moir's Guidebook*, Dr George Moir informs us that at Glade House there was still "no bridge over the Clinton River so everyone must needs be rowed across to where the track commences on the other side". Indeed this remained the case for a number of years. The flood-prone river was eventually spanned by a succession of three swingbridges, each being swept away in turn. The loss of the third Clinton swingbridge in the high floods of 1978 caused an early closure of the track for that season. The bridge was rebuilt during the winter with the

THE FINEST WALK IN THE WORLD

Track walkers crossing the Arthur River by boat in the 1960s. *(R. Willett)*

The Sutherlands' Chalet at Milford. *(Burton Bros)*

Left: Sandfly Lodge which opened in 1920 but was totally destroyed by fire six years later. *(C. Kerr)*

Right: Remains of the brick chimney at Sandfly Lodge, 1998. *(J. Hall-Jones)*

MILFORD SOUND

Mackinnon Pass was erected in 1928 by Ivan Latham, but being in such an exposed position it has been blown down with monotonous regularity. In 1947 Bill Anderson re-erected it for the third time and in 1957 a new pre-fabricated hut was air-dropped on the pass. In 1969 the pre-fabricated hut was replaced with an A-frame hut, which looked more secure. Nevertheless it went the way of all its predecessors and in 1982 it was replaced with a brand new hut with separate rooms for guided and non-guided walkers.

Missing Tramper

During the 1919-20 season, Miss Reid, a teacher from Dunedin went missing on the Mackinnon Pass. Without the permission of the guide she had

Left: The original Mackinnon Pass shelter hut, which was built in 1928 but re-erected three times. Mt Elliot in background.
(R. Willett)

Below left: The 1969 A-frame hut, the third hut on the Mackinnon Pass. Previous shelter hut in background.
(C. Kerr)

Right: Mackinnon Pass lookout, perhaps the place where Miss Reid fell to her death. The Quintin huts can be seen far below.
(R. Willett)

gone ahead while snow lay on the pass and was never seen again. A party returning over the pass had met her as she arrived on top but that was the last that was seen of her. It would appear that she missed the track in the snow and fell over a precipice. An extensive search was carried out by a number of men including the celebrated climber, Samuel Turner, conqueror of Mt Tutoko, who searched beneath the cliffs of the pass and Mt Balloon but found nothing. Turner even conducted an underwater search of the tarns on the pass.

A Piano for Quintin

One of the most delightful stories in Bill Anderson's book *Milford Trails* is how his team of volunteers manhandled a piano all the way from Milford to Quintin huts. Bill's wife, May, yearned for a piano at Quintin so during the winter Bill hatched a plan. He purchased a second-hand piano at Todd's auction rooms in Invercargill, and the piano was kept intact in its case with plenty of packing around it. Two pairs of flanged wheels were obtained and their axles clamped to the bottom of the case to provide locomotion. These would run on three sets of steel rails, each three metres long. As the piano trolley rolled over one set of rails the set would be shifted ahead in leapfrog fashion.

In December 1955 the piano was transported across to Sandfly Point by launch and then began the initial test of the system, the first leg of the journey along Hume Road to Doughboy hut. By coincidence a dinghy was being transported along Hume Road at the same time and the event became known as the great "piano-boat race". There is no record of any bets being placed, but the "piano-pushers" won and the piano was transported up Lake Ada to Boatshed hut by the Lake Ada boat. Then began the real test, the rough stretch of track from Boatshed to Quintin. The team split up into two with "piano-pushers" and "rail-setters", the latter having the harder task 'taking-up' and 'laying-down' the rails. Large boulders were overcome by allowing the rail section to 'see-saw' over them. Eventually on 23 January 1956 the piano was trundled into Quintin huts having been manhandled all 13 miles along the track from the Milford end. Amazingly, although "it had played an involuntary tune now and again with the occasional knock on the way", it required no tuning. The toilers were rewarded with "a first-class musical evening" by the pianists of a party staying at the huts that night. "Evenings such as this in the years that followed never failed to remind me that we were repaid a hundredfold for our labours", concluded Anderson. Today, although tuneless and replaced by a helicopter-delivered piano, Bill Anderson's piano is preserved in an historic corner of Quintin huts.

Modestly, Anderson points out that the piano he donated to the Quintin huts was not the first piano on the Milford track. In 1925 a piano was installed at Glade House, but this was delivered to the head of the lake by the *Tawera* and then rowed up the Clinton River by dinghy.

William ("Bill") Anderson, veteran manager at Quintin huts, who in 1955 devised a scheme to manhandle a piano to the huts. *(R. Willett)*

Bill Anderson's famous piano is preserved in an historic corner of Quintin huts. *(J. Hall-Jones)*

Pompalona in the Early 1930s

Keown Shirley, who worked at Pompalona hut in 1932 when his grandparents Mr and Mrs. Sam Gordon were in charge, gives an interesting

Sam Gordon washing the linen by hand at Pompalona hut, 1932. *(K. Shirley)*

Right: Mrs Gordon, balancing precariously on a stack of firewood, hangs out the washing at Pompalona hut, 1932. *(K. Shirley)*

account of Pompalona in the early 1930s. In those days there was "no electricity, no refrigerator and no washing machine", but the Tourist Department still insisted upon "starched white linen table cloths and napkins for the dining room and two clean sheets per person at each hut". So every day after the walkers departed, "the whole staff had to set to and cut firewood, boil up the copper, wash the linen with a wooden scrubbing board and put it through the hand-wringer, which was kept very tight to get rid of as much water as possible." Then on hanging it out to dry it was fingers crossed that there would be "more wind than rain" to get it dry before the next party arrived.

Then there was the baking to be done in the wood-fueled oven. Homemade bread, scones, biscuits and cakes. Bags of flour and sugar for the baking and tinned meats were brought in by packhorses, of which "Darkie" was the most cunning and always got his own way. "If burdened with an extra pound over his usual load he simply refused to budge until it was corrected. Usually he condescended to ford the Clinton River with his load but if the river was one inch higher than normal he demanded to be taken across by the punt, which was upriver from the present swingbridge. Darkie also had a nose for peppermints, which he never failed to wheedle out of any innocent tourist that were carrying them."

The Freedom Walkers

In 1964 members of the Otago Tramping Club, outraged at having to pay an exorbitant fee to the Tourist Hotel Corporation to simply walk the Milford Track determined to "buck" the system. In what became known as the "Freedom Walk" they set out in May 1964 to walk the track, deliberately without paying, to demonstrate their belief that it was a New Zealander's right to use the track without charge. They made their point and in 1966 a sympathetic Fiordland National Park Board erected huts at Clinton Forks, Lake Mintaro and Dumpling

Clinton Forks warden's hut which toppled into the Clinton River in 1989 after a flood eroded the river bank. *(Southland Times)*

An avalanche from Castle Mt sweeping down the gully above Pompalona huts. *(R. Willett)*

The remains of Pompalona hut balanced precariously over the eroded bank of the Clinton River after the avalanche and flood in 1983. *(DOC)*

and in 1998 the Clinton Forks hut was replaced by a new complex closer to Glade House, known as Clinton hut.

Pompalona Avalanches

With an avalanche gully running off Castle Mt high above, the Pompalona huts have always been at risk to damage by avalanches. The first time it happened was in 1925 when the huts were wrecked by the blast from an avalanche. Then on 23 September 1983 a mighty avalanche swept down the gully damming the Clinton River. When the river eventually burst through the dam the bulk of the Pompalona Lodge complex was swept away by the force of the tidal wave. The remainder of the complex was left balancing precariously over the eroded bank of the river. Fortunately it was before the start of the tourist season and there was no one inside the complex at the time.

Within the remarkable period of only six weeks a completely rebuilt Pompalona Lodge was opened on 3 November 1983, on safer ground well back from the river and the avalanche gully.

Hill for the use of the "Freedom Walkers", or unguided "Independent Walkers" as they have now become known. The huts are well staged so that the unguided walkers keep a "jump ahead" of the guided walkers each day, separating the two groups.

Sited on the bank of the Clinton River the Clinton Forks hut has always been in a precarious position. On 15 December 1989, after a flood in the Clinton River eroded away the bank the staff accommodation quarters toppled into the river. Further erosion of the bank occurred during the following years

The Pompalona area has always been prone to avalanches and during the heavy snowfalls of the 1994 season walkers were flown over this section by helicopters for nearly two months. Walkers who are forced to remain at Pompalona Lodge because of bad weather are awarded a "Pomp and Circumstance" certificate.

Hut Death

In 1950 there was a tragic death in the trackman's hut at the 4 mile post. The hut caught fire one night and the occupant trackhand Ike McCann perished

Chimney remains of the burnt 4 mile hut as seen in 1972. *(J. Hall-Jones)*

Above left: The original Milford Hotel built in 1928 to replace the Sutherlands' Chalet. Note long sheltered walkways to wings. *(H. Gough, 1939)*

Left: Remains of the kitchen block after the second fire in 1959. *(E. H. Buckley)*

in the blaze. The remains of the chimney of the hut can be seen just past the 4 mile post on the opposite side of the track.

Milford Hotel Fires

In February 1950, the year that the Tourist Hotel Corporation (THC) took over the Milford Hotel and track from the Tourist Department, the east wing of the hotel caught fire and was destroyed. The hotel was a vital link in the track in those days before the road was opened, so the track was closed for two years while the hotel was rebuilt.

In 1959, at the beginning of the season, the Milford Hotel caught fire for the second time. It started in the kitchen and before the fire could be brought under control it gutted the whole centre of the building including the

Left: A. H. Reed (later Sir Alfred) reaches the summit of Mackinnon Pass at the age of 88. *(R. Willett)*

Far left: "Ginger" investigates the foodstore at Mid hut. *(R. Willett)*

of the tractors was considerably shorter than the horses and today the huts are serviced by helicopters, or fixed wing planes landing at the Quintin huts airstrip.

In 1947, the year that the track was reopened after the war, my brother Gerry and I walked the track in two days, bypassing the Quintin huts and hitching a ride down Lake Ada in the boat. 51 years later, at the age of 71, I walked the track again, this time in conventional stages! Half a century on, I found that the Milford Track had lost nothing of its magic. It is still "a fine walk", *one* of the finest in the world.

administration block. The damage exceeded that of the 1950 fire, but with commendable zeal the hotel was rebuilt in time for the following season.

The lull in the use of the track seemed an opportune time to replace the packhorses with tractor transport. For the horse-lovers it was a sad day to see the last of the packhorses which had served so well since they were introduced by Dore in 1906. But to the wet-weather tramper it was a blessing to do away with the slush of manure-churned mud on the track. Also the barbed wire fences and gates which added nothing to the scenic beauty of the walk. The era

Right: Andy Richmond shoeing packhorses at Glade House at the beginning of the track season. *(R. Willett)*

CHAPTER 9

Te Anau and the lake steamers

Our captain was an 'Amurrikan' six feet long and three feet wide; of easy disposition, easy manners and the very essence of placcid good nature.
W. McHutcheson, 1891.

The discovery of the route through to Milford Sound was the genesis of the tourist town of Te Anau at the foot of the lake. Up till then no one lived in the sheltered little bay, Gantry Bay, tucked snugly in behind Lagoon Point (now called Bluegum Point). There the bracken and manuka scrub grew wild right down to the lake's edge. The only sign of man was a gantry, for unloading wool bales when the Melland's wool boat, the *Takahe*, brought wool down the lake to be picked up by bullock wagons and carted through to Invercargill. Richard Henry, who had arrived in 1883, lived in his thatched hut two kilometres round the shoreline towards the outlet of the Waiau River and Quintin Mackinnon, who arrived in 1885, lived in his log cabin across the lake at Garden Point.

After the opening of the Milford Track Thomas Brodrick, the skipper of the *Takahe*, with a certain shrewd insight made plans for the expected influx of walkers and tourists at the lake. He had in mind placing a tourist boat in Gantry Bay, a sheltered harbour he knew well. If the proposed coach road to the foot of the lake came to fruition he should do well, he reasoned.

"Old Brod" or "Old Broad", as he was sometimes called because of "immense width", was a Newfoundlander, "a rough old pioneer with a keen sense of humour and full of anecdote", Katherine Melland informs us. "He was capable and full of resource but not fond of work for work's sake. He drifted our way from the lumber camps of Canada and soon fell under the spell of Te Anau, taking a deep personal interest in it. For many years the *Takahe* was the only vessel on Lake Te Anau and often Old Brod used it to take a stray tourist up to the head and down again, on which occasions he was delighted to act as captain and crew of the little 15 ton boat, also as cook, general provider, guide, philosopher and friend."

In 1889 with the prospect of making his fortune from tourists "Old Brod" departed from Te Anau Downs Station and journeyed to Invercargill where [with assistance of entrepreneur William Todd] he purchased a "poor little old steamer", Katherine Melland continues. "He had her cut in half and conveyed to the lake with great difficulty by a huge bullock team to each half. Almost all the way was [still] without road and the journey lasted weeks. In the course of time the two halves were joined together, with a bit added to the middle and the weird little craft safely launched on Lake Te Anau. A bottle of whisky was

Te Anau Downs station in 1869 with the woolboat *Takahe* sailing in Boat Harbour. *(Alexander Turnbull Library)*

broken over the bow [of the *Te Uira,* as she was named] but not a drop of the contents was wasted! The boiler and engine were very poor and the only fuel was firewood, so at the very best seven miles an hour was the maximum [possible] speed. But as Old Brod who was captain, engineer and crew was quite unused to machinery and was by nature both dirty and lazy, the top speed soon became four to five miles an hour and breakdowns were frequent."

Brod retained the Maori name for lightning for the *Te Uira* until this became loosely interpreted as "greased lightning" and he got sick of being chaffed about it. He changed the name to *Ripple* and "was rather proud of his choice until one moonlight night after three breakdowns on three successive trips some [wag] painted a large "C" in front of *Ripple.*"

Brodrick's house and boatshed, the first two buildings at Te Anau. The boatshed is on the site of the present Fiordland Travel office. Note carpet of fern along the future Te Anau Terrace. *(Burton Bros)*

Left: The *Te Uira* moored at the Te Anau wharf, 1898. Captain Duncan's house in background. *(C. Ross)*

The *Te Uira* was kept moored at a little jetty in Gantry Bay and Brod built his boatshed and house immediately behind the wharf (now the Fiordland Travel Co wharf) and these were the first two buildings on the site of the town of Te Anau. Brodrick was living there when William Snodgrass arrived in 1890 and built the original "Lake Te Anau Hotel". About the same time Captain Melville Duncan, an ex-British Army officer, arrived on a sketching tour and was so enamoured by the wild scenery that he decided to stay on. He built his house and studio along towards Bluegum Point. And we have seen already how he acted as Mackinnon's agent at Te Anau. The Ross brothers, Donald and Jack, who succeeded Mackinnon as guides on the Milford Track, also erected their little hut on the waterfront. Close to Brod's house was the Marakura

"Old Brod" lounging on the deck of the *Te Uira* on Lake Te Anau. *(E. Govan)*

Captain Melville Duncan receives visitors in the garden of his residence at Te Anau, 1901. *(M. McGeorge)*

"Black Jack" McKenzie's stage coach outside the Ross brothers' hut at Te Anau. Jack Ross (extreme left), then Donald Ross. Capain Duncan's house in background. *(A.A. Southland)*

private hotel where the Garveys were managers until they moved to Glade House.

In 1891 William McHutcheson arrived by coach at Te Anau describing it as a "city" consisting of "one large inn, two small steamers, one four-horse coach, and as our friend Paddy would say, half a dozen other buildings".

"We were deposited on the pebbly beach of the lake at 10 am", recounted McHutcheson, "eagerly anticipating that the steamer [the *Te Uira*] would be ready for an immediate start,

skipper who, from his snug seat by the funnel, beamed satisfaction and encouraged us with approving remarks of a complimentery character. The last stick of manuka having been safely hoisted aboard, we ran up our tattered ensign, blew our asthmatical whistle and stood out to sea, finally heading straight up the lake at 1.30 pm with what the skipper facetiously called a 'full head' of steam on."

With "full bustin'-power in the toobes" they cruised up the lake at a maximum speed of three knots, the passengers "lounging about more or less dozing". Suddenly a "startled cry of 'fire, fire!' rang through the ship waking us from our lethargy. 'Where's Brod? Where's Brod?' cried the alarmed passengers as they raced frantically around the deck of the *Te Uira* looking for the captain. Then through a rift in the smoke we saw Brod lean leisurely from his seat by the funnel, quietly dip a bucket over the side and calmly extinguish the whole blaze in a moment. 'Yees needn't be skeered bhoys,' he remarked reassuringly, setting down the empty bucket. Then removing his pipe he expectorated with great judgment on the last red spark, 'I ginerally douse the glim once or twice

The *Te Uira* "buries her fine Roman nose" in the beach at the mouth of the Clinton River. "Brod" standing at the stern. *(E. Govan)*

enabling us to make the head of the lake by sunset. The first glance at our steamer and crew convinced us of our error. Neither had steam up and neither looked as if they had been built to get it up hurriedly". On inspection the steamer looked the "essence of disorder" while the crew [Brod] turned out to be an "Amurrikan, six feet long and three feet wide; of genial disposition, easy manners and the very essence of placcid [sic] good-nature. In answer to our queries the skipper said steam might be got up in two hours; but we would then require to run two miles across the lake [to Brod's Bay] to load up with firewood for the trip". Anxious to avoid any delay McHutcheson's party innocently volunteered to load up the firewood themselves, an offer that was accepted with such alacrity that it astounded them, until they learned afterwards that similar offers were made by other impatient travellers and immediately accepted by the astute Brod.

"A couple of hours later, therefore, saw five horny-handed sons of toil perspiring freely under a broiling sun, loading up firewood from the beach under the supervision of the genial

The *Te Uira* (renamed *Ripple*) beached at the start of the track to Glade House, 1898, before the wharf was built. *(C. Ross)*

doorin' the trip', he drawled quite unruffled."

It was not until the next morning at the ungodly hour of 1 am that the *Te Uira* finally made it to the head of the lake where she arrived with a bang, literally, "burying her fine Roman nose" on the beach of the Clinton River. The passengers scrambled over the side and made their way up to the Clinton hut where, as we have seen, they were welcomed by Captain Melville Duncan.

The Tawera

During the winter months when the Milford Track was closed Donald and Jack Ross used to cut firewood for Old Brod's steamer, usually across the lake at Brod's Bay. But they ranged as far afield as the Snag Burn in the Middle Arm where in 1898 their dog caught a live takahe (notornis), the last to be recovered until the rediscovery of the species in Takahe Valley in 1948 by Dr G. Orbell.

As the season went by the Ross brothers grew tired of chopping wood for Brod's steamer and they decided to build one of their own. As guides on the Milford Track they had seen the need for a larger, modern steamer on the lake, one that ran regularly, without breakdowns and without the indignity of asking the passengers to produce the fuel! They formed a little syndicate "Donald Ross & Co" and on being promised a government subsidy of 200 pounds a year they instructed the Dunedin Foundry & Engineering Co to build a steamer at a cost of 2,200 pounds.

The steel hull, "70 feet long", and Gardner steam engine "were pressed at the foundry in the presence of the government inspector of machinery, Jake Morrison". During 1898 the hull was transported in sections by rail to Mossburn

Jack Ross, with his dog Rough which caught the takahe at the mouth of the Snag Burn in 1898. (M. McGeorge)

The Tawera *being assembled at Bluegum Point. Captain Murray-Menzies (with cap) at the foot of the ladder. Note how the sections are all labelled alphbetically. (J. Watson)*

and then on to Bluegum Point, Te Anau, by two teams of bullock wagons. William Harrison records how the journey from Mossburn to Te Anau by the bullock wagons took three and a half days with one team of eight bullocks losing its footing in crossing the Mararoa River and having to be dragged out more dead than alive. The engine was carted later by a team of horses. The vessel, with the hull sections all labelled alphabetically, was assembled on the shore in the little bay at Bluegum Point and was inspected by the engine designer, W. Gardner, and the government inspector, Jake Morrison, prior to the launching on 22 February 1899.

On that day the completed steamer was all decked out in bunting and the local population congregated at Bluegum Point in their Sunday best for the launching and naming of the *Tawera*. The name was taken from the Maori for the Morning Star (the planet Venus) and an emblem of the "star" was fixed on the bow.

One week after the launching, on 1 March, the proud owners invited 45 guests aboard the *Tawera* for a special excursion up the South Fiord. "The steamer lying serenely alongside the pier", records the *Southland Times*,

"presents a handsome sight, painted in a bronze-green with a yellow stripe, and white below the water-line. The steering gear is on deck in front of the funnel to facilitate the work of the man at the wheel. There are two cabins, one aft for 10 ladies and one forward for 20 gentlemen. Both are fitted with lavatories daintily painted in lavender and white".

"Shortly before noon", continues the report, "the *Tawera* with 45 passengers aboard [and Captain Robert Murray-Menzies at the helm] steamed away from the pier. The party was in great spirits and cheers were given for the builders, the owners and the captain. Although several sharp gusts of wind were immediately encountered, the little vessel met each gallantly plunging into troughs and then riding on the waves. Many times the spray dashed on to the starboard deck amusing the favoured ones on the lee side. As they approached the South Fiord a sharp squall sprang up and the vessel entered the arm instead of continuing up the lake. Then on the run home with the wind behind them they reached a [top] speed of 12 knots"!

Bullock wagon arriving at Bluegum Point with the funnel for the *Tawera*. *(H. C. Burrows)*

Launching of the *Tawera* at Bluegum Point, 22 February 1899. Captain Murray-Menzies at the helm. Note Morning Star (Maori, Tawera) emblem on the bow. *(J. Watson)*

Safely back at the pier the passengers disembarked and headed straight for the dining room of the Lake Te Anau Hotel for the "excellent repast" that had been prepared by the hostess, Mrs W. Snodgrass. Afterwards they adjourned to the "cheery fire" of the parlour where "all present extended to Messrs Ross & Co the heartiest good wishes in their venture". The steamer had cost the Ross Brothers 2,200 pounds but they had been assisted by the government subsidy and they were to regain their money when the Tourist Department purchased the *Tawera* in 1906.

Captain Robert Murray-Menzies, who had his master's ticket quickly established a regular service by the *Tawera* to the head of the lake for the start of the Milford Track. There was only one incident during his six years in command when, in 1901, the steamer broke adrift from the Te Anau wharf and

MILFORD SOUND

foundered on the beach at the foot of the lake. It took five days to get her off, then instead of firing up the boiler she was towed back to the wharf by a team of bullocks. Murray-Menzies became a financial member of Donald Ross & Co and employed a man to work the coal pit up the Upukerora River so that the *Tawera's* boiler could be fired more efficiently with coal instead of wood.

Unfortunately the able Murray-Menzies became ill and died on 2 May 1906. Temporary skippers filled in until 22 December 1906 when Captain Thomas ("Tom") Roberts arrived and took over command to carry on for at least 16 years.

For a number of years the government continued to subsidise the *Tawera* service by 200-300 pounds a year without any return, in spite of repeated recommendations from Superintendent T. E. Donne of the Tourist Department that the government purchase the steamer. "The private owners", he pointed out in his annual reports, "cannot see their way to run cruises to the several arms where some of the best scenery of the lake can be seen". Under government control such cruises could be introduced. Donne eventually got his way and on 30 January 1907 the government purchased the *Tawera* and also the Te Anau Hotel, for the total sum of 2,500 pounds. With its previous purchase of Glade House in 1903 the government now had complete control of the track including its access.

One of the first actions the new owners carried out was to build a wharf at the head of the lake. Up till then the *Tawera* had simply "buried her nose"

Above left: The original Lake Te Anau Hotel built by William Snodgrass in 1890. *(C. Ross)*

Below left: Glade House wharf being built in 1908. Captain "Tom" Roberts (far left). *Tawera* berthed alongside. *(Y. Dore)*

Right: Two *Tawera* skippers, Lawson Burrows (left) and "Robbie" Robb. *(C. Robb)*

Tawera (note tall funnel) berthed at the Te Anau wharf, 1900. Brodrick's old boatshed still beneath the bluegums, then the Marakura Hotel, the Ross brothers' hut (partially obscured by trees), Captain Duncan's house in the distance. The shadow in the foreground is from the Te Anau Hotel. *(Alexander Turnbull Library)*

in the gravel of the beach. Logs for wharf piles were felled and floated down the Clinton River to the beach where they were driven into the stones with a piledriver shipped up the lake on the *Tawera*. It took two months to build but by August 1908 the wharf was completed.

With the government taking over the *Tawera* the route was extended to include "a run up the picturesque North Arm on the way to the head of the lake and the South Arm on the down journey". These excursions quickly proved "very popular" and there was a marked increase in passenger numbers. But cruises on Sundays had to be dropped because of "objections by certain church authorities"!

As the years went by passengers began to complain about the slow speed of the *Tawera*. In 1928 the original steam engine was therefore removed and replaced with an up-to-date 100 horse-power diesel engine. Stevenson & Cook of Port Chalmers did the conversion work, at the same time replacing the *Tawera*'s distinctive tall funnel with a much shorter one. On a trial run the rejuvenated *Tawera* reached a top speed of 11.8 knots!

In 1954 Lawson Burrows, the rediscoverer of the Te Anau glow-worm caves, and Wilson Campbell chartered the *Tawera* from the government for two years, eventually buying it from the Tourist Hotel Corporation in 1956. As well as continuing the service to the start of the Milford Track the adaptable Burrows also erected jetties all round the lake and would pick up trampers and hunters whenever and wherever they requested. A genial, practical joker he went to some considerable trouble to sling a lawnmower high in the trees at Moa Point in the South Arm so that he could point out the 'moa' to credulous tourists.

Lawson's son, "Snow", and Robert ("Robbie") Robb also served as skippers on the *Tawera* and the former confirms that 'some' member of the crew used to distil a 'sort of whisky' in the engine room. The author can vouch for this when he and other members of a Canterbury Museum expedition innocently (but willingly!) accepted the illicit product after being picked up at the head of the South Arm.

In 1966 Burrows and Campbell sold out to Les Hutchins, the founder of Fiordland Travel Co. which kept the *Tawera* on the service to the head of the lake, operating on a shorter leg from Te Anau Downs instead of the full length of the lake from Te Anau.

Sadly, in August 1997, on its annual inspection the *Tawera*'s steel hull was found to be rusted beyond repair and the "grand old lady of Lake Te Anau" was decommissioned. She was only 18 months short of her 100th birthday.

A rare photo of the *Tawera* with sail up. Note much shorter funnel after conversion to diesel in 1928. *(C. Robb)*

CHAPTER 10

The Grave-Talbot track

The track across the mountains will never be as easy as that over the Mackinnon Pass, yet all who are energetic enough will find no difficulty in crossing by our route.
W. G. Grave, 1910

Now that there is a fine highway giving easy access to Milford Sound it is almost forgotten that the road was preceded by a track from the Hollyford Valley through to Milford Sound.

Back in the early 1900s T. E. Donne of the Tourist Department was keen that someone should discover a more direct route from Lake Wakatipu through to Milford than the Milford Track. In 1907 W. G. ("Bill") Grave, whose remarkable series of explorations through to the West Coast Sounds were already legendary, agreed to explore the Cleddau Valley and look for a way.

Arriving at Milford Grave's party (consisting of Grave, Arthur Talbot, Alfred "Gulliver" Grenfell and Basil de Lambert) discussed the possibilities with Sutherland. He told them of a low pass (later called the Darran Pass) at "the head" of the Donne Valley branch of the Cleddau, which he said would lead to Lake Wakatipu. He also gave them a map showing the pass at "the head" of the Donne Valley, as observed from further down the valley. (It can be seen from the Donne bridge.) Unfortunately the Donne Valley curves well away to the north (see endpaper map) from the line of Sutherland's view and its true head was nowhere near the position given on his map. In this way Grave's party bypassed Sutherland's Pass as they slogged their way up through the bush and so by far the easiest route through the mountains remained undetected for almost 50 years. Sutherland's Pass was first ascended

Arthur Talbot (standing) and Albert Lyttle exploring around Lake Adelaide in 1908. Both were later killed in the First World War. *(Alexander Turnbull Library)*

William ("Bill") Grave with heavy pack on. *(J. S. Mackay)*

Sutherland's Darran Pass, which would have been a much easier route for the Grave-Talbot track and perhaps the Milford road. Donne River in foreground.

from the east via Lake Adelaide by Gerry Hall-Jones and Malcolm Imlay in 1955, when they observed easy ledges leading down to the Donne Valley floor. Dr Richard Stewart's party completed the first crossing of Sutherland's Pass in 1962 naming it the Darran Pass. As Gerry Hall-Jones points out an earlier recognition of Sutherland's Pass could have led to a much easier route for the Grave-Talbot track and perhaps the Milford Road.

Having missed Sutherland's Pass in the Donne Valley Grave's party followed the Gulliver branch of the Cleddau to its head where the expedition was halted by the unscalable looking cliffs of the Gertrude Saddle down which poor Quill had plunged to his death. It was only afterwards when they examined the expedition's photographs together that Basil de Lambert spotted a valley leading off the Gulliver where there appeared to be a slight 'hope' of a climbable route above a waterfall (De Lambert Falls). Inevitably the scholars called it the Esperance Valley.

In 1909 Bill Grave, Arthur Talbot and Albert Lyttle returned to the attack, this time from the Hollyford Valley side. Descending from the Lake Howden hut into the Hollyford Valley they followed it up to a large open "natural park" (as marked on Preston's map) which they called "Lyttle's Farm", a jocular name originating from Lyttle's doctor who asked if he was going to look for a farm in the Hollyford Valley. Continuing up the valley they camped at "The Forks", the junction of the Gertrude and Homer Steams. On 5 January 1910 they ascended Homer Saddle but concluded that there was no obvious route down into the Cleddau Valley from there. By now Lyttle was feeling unwell, so leaving him behind Grave and Talbot climbed up a steep narrow ridge from the saddle (Talbot's Ladder) and continued on to make the first ascent of Mt Macpherson (which they called "Snowball"). From the summit of Macpherson they found that they were looking straight down on 'their' Esperance Valley of 1907.

Returning to their camp at "The Forks" Grave and Talbot set out next morning determined to get right through to Milford. By 1 pm they were back on the top of Macpherson and from there began the difficult steep descent into the Esperance Valley. All went well until they came to a 150 metre precipice. Descending by rope

Right: Homer Saddle and Talbot's Ladder leading up from the right end. From the head of the Hollyford Valley. *(J. Hall-Jones)*

Boulder lying across Lyttle's Dip which the climber has to pass beneath. Esperance Valley immediately below. *(A. C. Gifford)*

Right: Hoani Jennings (in lead) and Brian Johns ascending "the ledges" from Esperance Valley in 1925. *(D. R. Jennings)*

Grave (left) and Talbot on summit of Mt Gulliver looking down at Talbot's Ladder and the Homer Saddle (below). Mt Macpherson in centre with the first icefield on its left leading through a gap, Lyttle's Dip, to the second icefield and the Grave-Talbot Pass beyond. *(J. S. Mackay)*

they pulled it down behind them, cutting off any hope of retreat. They had to carry on! By 9 pm it was dark and they decided to camp, but when they awoke in the morning they found to their horror that they had camped within a few metres of another precipice. Eventually they made their way down by some rock "ledges" into the bed of the Esperance Valley. They continued down the Gulliver Valley to the Cleddau junction where they picked up "the tracks of Sutherland's cattle" and followed them out to Milford, arriving there on 7 January 1910. The long-sought direct route to Milford had been found and the pass was deservedly named the Grave-Talbot Pass.

From Milford the explorers returned by the Milford Track and Harry Birley's Pass to the Lake Howden hut, completing the round trip.

At the end of the same year Grave, Talbot and Lyttle set out from Milford to recross their pass, this time hoping to avoid the precipice where they had made their perilous descent on the rope and the unnecessary ascent of Mt Macpherson. To save climbing over the awkward bluff on the north bank of the Cleddau River (later carved out for the road) they followed the trail of Sutherland's

THE GRAVE-TALBOT TRACK

Left: David Jennings on the top of Talbot's Ladder, 1922. "The Forks" in the Hollyford Valley below and Mt Christina on skyline.
(D. R. Jennings)

Right: Professor James Park visits the students at Howden hut in 1920. In front, from left: Guide Jock Edgar, Prof. Park, Jim Church, Tim Taylor and Alec Kirker. At back, David Jennings and George Moir.
(D. R. Jennings)

from Mt Cook across their pass to report on it. The district engineer from Dunedin also wrote a report providing details of the work required to construct a track over the new route and extolling it as a grand round trip for the Milford Track walker.

The Student Track Cutters

In 1914 a geology student, C. A. King was looking for a project to write his thesis on. His Professor of Geology, P. Marshall, was aware that the Tourist Department had funds available and he suggested a track cutting vacation in the Hollyford Valley, where King could study the rocks. A fellow geology student, R. A. W. Sutherland, joined King; also W. Ward, a law student and L. A. McKenzie, a teacher. The Tourist Department agreed to employ them and put guide Jack Lippe in charge of this first student working party on the Grave-Talbot track. But Lippe was more at home among the glaciers of Mt Cook than the tangled bush of Fiordland, particularly when trying to supervise a gang of lively young students. During the 1914-15 summer season this original party cut a track from the Lake Howden hut almost directly down to the Hollyford River (the steep track was known as "Lippe's Mistake") and then upriver to Falls Creek. No mean effort for the first season.

After this initial burst of activity all work ceased on the track until after

cattle up the opposite bank and crossed the river higher up to enter the Gulliver and Esperance Valleys. This time they kept well clear of the Esperance precipice by ascending the rock ledges and avoided Mt Macpherson by passing through Lyttle's Dip between two snowfields. They then descended Talbot's Ladder to the Homer Saddle and the Hollyford Valley below.

The government was immediately interested in the new route to Milford and during the summer of 1911-12 Grave and Talbot took surveyor Duncan Macpherson (after whom Mt Macpherson was named) and guide Jack Lippe

The students' Blowfly camp at Camera Flat, 1919. From left: Jock Lippe (supervisor), Joe Tanner, Bill Grave, David Jennings, Dan Crawford, Merv Harris. *(D. R. Jennings)*

Students' Cirque Camp, 1920. From left: David Jennings, Jim Church, Tim Taylor. Photo entitled, "Stewed kea on for tea". *(D. R. Jennings)*

the War. Then from 1919 to 1924 David Jennings annually mustered parties of his fellow medical students to work on the track during summer vacations. Guide Lippe was put in charge again for the first two seasons, but as David Jennings records "they found him as close as an oyster, with no repartee and made no reply to our ribald comments", which were doubtless enriched by medical jokes and student songs. On the other hand Bill Grave frequently visited the track-making parties and was always popular among the students, who later named a dominant peak in the Tutoko Valley, Mt Grave, after the indomitable explorer. Lippe apparently got the message and departed after two seasons leaving the enthusiastic Jennings in charge and to keep the track diary, which he did most conscientiously.

During the first season (1919-20) the students reopened the track down to the Hollyford River, "Lippe's Mistake" or as they called it "Gentle Annie". It really was an "awful track", wrote Jennings to his mother, "with 34 zig-zag turns and one particularly bad spot which we called 'Concentrated Hades'."

At Falls Creek they slung a rope bridge over the creek and crossed to establish a camp beyond at Camera Flat, calling it "Blowfly camp" because their blankets and clothing got badly flyblown. Continuing the track to "Lyttle's Farm" they named Mt Crosscut after the blunt crosscut saw they were using, "wishing that their saw was as sharp as the peaks of the mountain"!

For the 1920-21 vacation they were joined by George Moir, a returned soldier and the only non-medical student in the team. "Moir had the habit of slinging advice about by the yard", records Jennings, in an interesting aside on the original author of *Moir's Guidebook*. "We were inclined to resent it at first but we learned to throw off at him gently and keep the camp amused."

They were pleased to find that their rope 'bridge' across Falls Creek was still intact, but in spite of this Tim Taylor "tumbled into the pool with a plop" and had to be fished out. Later a proper wire swingbridge was slung across the

Falls Creek before the bridge. *(D. R. Jennings)*

when they laid out the road to the Homer Tunnel. Students Peak in the upper Hollyford Valley was deservedly named in honour of their work.

The following season (1921-22) the students shifted their work to the Milford side of the pass. Arriving at Milford via the Milford Track they met Mrs Sutherland, by now a widow, and she showed them their billet which was the bunkroom at the back of the Sutherlands' chalet. This was

Below: Falls Creek swingbridge constructed by Dan McKenzie and the students in the early 1920s. *(A. C. Gifford)*

The students' rope crossing at Falls Creek before the bridge. *(D. R. Jennings)*

stream by Dan McKenzie of Martins Bay. The students carried the coils of wire hung around their necks all the way from Howden hut and referred to themselves as the "chain gang". During the construction of the bridge Jennings' brother Hoani 'accidentally' tipped Dan McKenzie off the wire into the pool. When the irate McKenzie surfaced his pipe was still clenched firmly between his teeth, but it was steaming instead of smoking!

In those days there was a bounty on keas of "seven shillings and sixpence" a head, because of their alleged attacks on sheep. "We have managed to get four so far", wrote Jennings to his mother, and a later photograph shows Jim Church carrying a tin in which they had nine heads. The flesh was not wasted and on at least one occasion Moir "went after a kea with a long handled slasher and bagged it for the stew".

That season they completed the track right up to the foot of the Homer Saddle, a track which proved to be of considerable assistance to the surveyors

Students carrying swag in the upper Hollyford Valley. From left: David Jennings, Jim Church (with tin full of kea heads for payment), George Moir, Tim Taylor. *(D. R. Jennings)*

David Jennings visiting Elizabeth Sutherland at The Chalet, Milford, in 1923. The boatman, Bill Thompson, standing below. *(D. R. Jennings)*

the beginning of a very happy relationship between the students and Elizabeth Sutherland, whom they regarded as a second mother. "She was a very lonely person", Jennings records, "but talked good common sense". The students repaid her for her many kindnesses by chopping wood and digging her garden.

Proceeding up the Cleddau Valley to the Tutoko River they forded it only to be confronted by the great bluff beside the river, which was later carved out for the section of road where the modern motorist gains his first view of Mitre Peak. Obstructed, they forded the Cleddau River and continued their track up the opposite side to the Gulliver junction where they "rigged up a flying fox" to recross the river and establish a base camp. Higher camps were placed at the Esperance junction and within 100 metres of the De Lambert Falls, where the Esperance hut was later built.

Kakapo caught (in 1939) in Cleddau Valley by a roadworker. Note handler wearing thick leather gloves for protection. *(H. Gough)*

The track cutters made full use of the trails through the bush created by Sutherland's cattle. One of the bulls "old Bovril", chased Tim Taylor up a tree, "pawing and snorting horribly" until Taylor jumped down yelling and waving his arms. Outchallenged, the huge bull turned in its tracks and scampered away to safety in the depths of the tall forest. Later they shot a cow, which was an unexpected "beef bonus" to the hungry students. Jennings utilised a piece of the cowhide to repair the seat of his pants.

As in the Hollyford, Grave visited the students, keeping an eye on their progress. He took Jennings to see the "stupendous chasm" (now known as The Chasm) that he had discovered while exploring the upper Cleddau in his search for a route through to the Hollyford. It is an "astonishing feature", records Grave, "down which the river rushes in a boiling cataract, the walls of which are excavated in enormous potholes". Grave also led the students up the Tutoko Valley, where the "kakapo boomed close to their tent and there were kakapo tracks everywhere in the bush. They are very clever ventriloquists and

THE GRAVE-TALBOT TRACK

it is very difficult to [locate] the log that the sound is coming from."

At the end of that season the students determined to cross the Grave-Talbot Pass to familiarise themselves with the complete route that they had been working on. On 26 February 1922 they set out from their Esperance bivvy near the De Lambert Falls. After climbing steeply up a ridge near the falls they ascended the rock "ledges" to reach the summit of the Grave-Talbot Pass ("5,600 feet, Moir") where they left an aluminium plate with their names and date perforated on it. Using totara poles as ice axes they pushed themselves across the two snowfields on either side of Lyttle's Dip and clawed their way down the "razorback edge" of Talbot's Ladder, "straddling their legs and hanging on by the seats of their pants". Reaching the Homer Saddle safely they continued down to the bush where they slept soundly after "eleven hours on the rope". Carrying on to their old "Cirque camp" at the upper end of Lyttle's Farm and "Blowfly camp" at Camera Flat they crossed the wire swingbridge at Falls Creek and ascended "Gentle Annie" to arrive at their old haven at Howden hut. There the hungry students borrowed some food from the Greenstone trackman Jock Edgar's store, repaying him when they met up in Queenstown.

Mt Tutoko

In January 1923 the climber amongst the students, Brian Johns,

Using totara poles to cross icefield on the Grave-Talbot Pass. Brian Johns (in lead) and Mel Aitken. *(D. R. Jennings)*

The "Johns' Tutoko Expedition". From left: Edgar Williams, George Moir (not in expedition), Bill Grave, Brian Johns. *(D. R. Jennings)*

Below: "High tea" on Mt Tutoko. From left: Johns, Grave, Williams. *(D. R. Jennings)*

"The Chalet", Milford, 1905. Donald Sutherland with dog in foreground. *(Hocken Library)*

Left: Brian Johns lowering packs during their descent from Tutoko. *(E. Williams)*

took a few days off track cutting to join Bill Grave and Edgar Williams in an attempt on the unclimbed Mt Tutoko (2,746 metres), the highest mountain in Fiordland. The egotistical Englishman, Samuel Turner, had already had three unsuccessful assaults on the mountain and the students were amused to find several large packing cases at Milford labelled "Turner's Third Tutoko Expedition". Christening themselves the "Johns Tutoko Expedition" the party made a determined bid on the south-west ridge of the mountain getting within "1,000 feet of the summit. Mr Grave cut steps in solid ice for 2,500 feet", records Jennings, "and couldn't do another foot when they had to turn it in. It was too solid for them."

In 1924 on his sixth attempt Samuel Turner, with the famous Peter Graham as his guide, finally conquered the great monarch of Fiordland. But the visibility was poor and it is typical of Graham that he insisted that they return two days later to make quite sure that they had indeed reached the highest point on the mountain.

End of the Sutherland Era

On their arrival at Milford for the 1923-24 season the students were distressed to learn that their "second mother", Elizabeth Sutherland had just died. Aged 80 she had passed away on 10 December 1923 (not 1924 as on her tombstone). The government steamer *Tutanekai* was in Milford at the time and

led by Captain John Bollons the students helped lay her to rest alongside her husband, who had predeceased her by four years, in a corner of their garden at the back of the hotel.

Elizabeth Samuel had been widowed thrice when she married Donald Sutherland on 7 August 1890 on one of his visits to Dunedin. On his return to Milford with his wife Donald's free and easy lifestyle was to be transformed completely. Elizabeth could see the need for accommodation for the walkers who were beginning to arrive off the track with nowhere to stay. She provided the finance to purchase a site and to build an accommodation house which she called "The Chalet". To provide fresh meat for "The Chalet" she also applied for a grazing licence for sheep, pigs and cattle, but as we have seen Sutherland's cattle soon ran wild in the bush.

The couple catered for up to 300 walkers each season until 1917 when Donald became ill and "The Chalet" had to close down. He died on 21 September 1919 before the beginning of that season. A large heavy man, Elizabeth was unable to shift his body which remained unburied until the arrival of Captain John Bollons in the government steamer *Hinemoa* five weeks later.

Described by George Moir as "The Mother of Milford Sound", Elizabeth stayed on at Milford keeping "The Chalet" open in the summer until 1922 when she sold out to the Tourist Department for $2,000.

The grave of the couple who were responsible for developing one of New Zealand's most famous tourist attractions can be seen at the back of the present hotel.

First Ascent of Mt Talbot (Lippe)

As a finale for their last working holiday in 1924 the students determined to have a crack at the first ascent of Mt Lippe (later renamed Mt Talbot). They had met Tom Preston at the burial of Elizabeth Sutherland. Preston was surveying the completed Grave-Talbot track and they decided to combine forces for the ascent of Mt Lippe.

They were breakfasted and away by 5.30 am on 20 February 1924 and ascending the Esperance ledges by moonlight, four medical students on one rope and three surveyors on another. Reaching the top of the pass they remained high to skirt the base of Mt Macpherson and head across the snowfield towards Mt Lippe. As they pushed their way across the snow with their totara poles they thought they heard a shout from the summit of their objective. Wondering if they were hearing things they looked up and, to their amazement, spotted a party of climbers already on 'their' summit. "Pipped at the post" Jennings comments philosophically in his diary. Puzzled as to who their competitors were in this vast array of unclimbed peaks, they trudged on to Traverse Pass, below the summit, to meet George Moir, Harry Slater, K. C. Roberts and R. S. M. Sinclair. They had chosen that very same day to try for the first ascent, in their case starting from a bivvy on Gertrude Saddle, a much shorter route.

Although beaten to the summit of Lippe, the view from Traverse Pass was a reward in itself. It was a perfect day giving a grand panorama of all the peaks in the whole area including the two monarchs of Fiordland,

Left: Donald and Elizabeth Sutherland in later years. Maid and guide. *(Alexander Turnbull Library)*

Right: Memorial stone behind the present Milford Hotel. *(J. Hall-Jones)*

Left: The historic "summit meeting" on Traverse Pass, 1924. Climbers identified: David Jennings extreme left, Hoani Jennings, central figure in shorts, George Moir lowest in foreground. Ivan Ward, extreme right, standing beside Tom Preston. *(D. R. Jennings)*

Tutoko and Madeline. Far below lay Milford Sound "clean and glistening in the brilliant light".

After their "summit meeting" Jennings' party set off down their snowfield with giant long strides until Jennings tumbled into a crevasse pulling his party up with a jerk. "I lived through an age in that second", he wrote afterwards, but fortunately the rope held and his companions pulled him out.

At the finish of the season Dan McKenzie turned up and the students gave him a hand to put in a wire rope on the Esperance ledges. "They had to rope him up and hold on to him because he [tended to forget] where he was when he hit the rock chisel!" McKenzie survived to carry a crosscut saw, of all things, across the pass to begin pit-sawing timber for the first Homer hut. On the way there he knocked in a wire cable on Talbot's Ladder. Many years later an energetic practical joker went to some considerable effort to haul a wooden ladder up on to Homer Saddle so that he could point out "Talbot's Ladder" to credulous tourists.

Completion of the Track

Dan McKenzie and Bill McPherson were employed by the Tourist Department to build an alpine hut at the head of the Esperance Valley and another one at the foot of the Homer Saddle. Using pit-sawn timber cut on the spot the Esperance hut was constructed 100 metres below the De Lambert Falls early in 1925 and the Homer hut later that year.

For the construction of the Homer hut the corrugated iron roofing and glass window panes were packed by horse up the Greenstone track and then manhandled by McKenzie and McPherson all the way from Howden hut to the building site. The timber was pit sawn at The Forks and then lugged up the steep Homer Creek bed to the site. While erecting the hut the two builders lived in a small

Left: Esperance hut, 1953. Photographed by Scottish climber Hamish McInnes. *(K. Hamilton)*

Below left: Original shelter hut used by William McPherson (left) and Dan McKenzie while constructing the first Homer (McKenzie) hut. *(J. Ede)*

Below: Dan McKenzie (above) and William McPherson pit-sawing timber for the Homer hut. *(Southland Museum)*

crude shelter which they called "Terrier Camp", perhaps comparing it with a dog kennel. "It was a great kitchenette next a huge boulder", records David Jennings, "with slab and rock sides and an iron roof from our Cirque [camp] fireplace". The two-roomed Homer hut with its two entrance doors was completed by late 1925. An early visitor, Gordon Speden, recalls that its "freshly sawn timber, reddish coloured in the afternoon's sun, was a welcome sight at the end of the day". With justification the first

Homer hut was known as the McKenzie hut and the Esperance hut as McPherson hut.

Early parties starting on the Grave-Talbot track from Milford had to ford the Cleddau River, usually at the old river mouth where there was a wide delta, and cross back again at the Gulliver junction. In 1932 the Tourist Department, using the proven Dan McKenzie to do the work, erected a fine swingbridge wide enough for packhorses at this second crossing. Built of Australian hardwood with a wooden tower at each end to support

Completed Homer hut, Christmas Day 1925. *(Alpine Club hut, Homer)*

Right: Homer hut in 1938. *(George R. Chance)*

Below: Historic packhorse swingbridge over the Cleddau River on the Grave-Talbot track, 1999. *(J. Hall-Jones)*

the suspension cables, it survives today as an historic monument to the Grave-Talbot track. It can be seen by following down the track opposite the sign at the Gulliver road bridge (see Appendix B).

Demise of the Track

As Grave had made clear in his original report, "the track across the mountains will never be as easy as the Mackinnon Pass". The Swiss alpine guide Kurt Suter, who was also the Homer camp cook, lived in A. & W. Hamilton's corrugated iron hut next door to the original Homer hut and offered himself as a guide for the Grave-Talbot track. But only a small number of people made the crossing, usually experienced climbers.

In 1938 two young climbers, George R. Chance of Dunedin and John McLean, crossed the Grave-Talbot Pass to Milford Sound with Tom Cameron as their guide. On their return to the top of Talbot's Ladder a rogue boulder suddenly broke loose above them and came bounding down towards the three men. Miraculously it missed Cameron and Chance but unfortunately struck John McLean full on, killing him outright. Guide Cameron elected to stay with the body while George Chance hurried down to Homer camp to seek help. Alpine guide Kurt Suter quickly mustered a stretcher bearing party, then went ahead to carry the body down the difficult and dangerous Talbot's Ladder. Hoisting the dead McLean on to his shoulders Suter carefully picked his way step by step down the precipitous Talbot's Ladder, while Cameron remained above playing out a rope attached to the body in case Suter should slip and lose

it down into the Cleddau Valley far below. After two and a half hours exhausting work carrying the body slung across his shoulders, Suter finally reached the stretcher party waiting for him on the slopes of Homer Saddle. Only then did he relinquish his burden. "It was a remarkable feat", comments George Chance years later, "but a very sad and tragic end to our climbing trip". Deservedly the name Mt Suter was later given to a fine pyramidal peak in the upper Hollyford Valley.

Eventually when the Milford Road was opened the Grave-Talbot track fell into disuse. Both huts slowly deteriorated and the Esperance hut was finally dismantled. The original Homer hut became engulfed in the roadworks' Homer camp and in 1952 the site shifted down to The Forks where the Alpine Club took over two disused Ministry of Works huts. Then in a series of working bees over three years the club built the present Alpine Club hut. Appropriately it was opened in 1965 by Dr George Moir.

As for the students who constructed the track, they all did well in their respective fields: David Jennings, their enthusiastic leader, became a general practitioner in Invercargill and a foundation member of the Fiordland National Park Board; Hoani Jennings, who had tipped Dan Mckenzie into Falls Creek, became an obstetrician and gynaecologist; the imperturbable Tim Taylor, who had put a bull to flight, the director of anaesthetics in Christchurch; Brian Johns, the climber, a respected general practitioner in Auckland. Surveyor Tom Preston produced his map of the track in 1924 and George Moir compiled the original edition of *Moir's Guidebook* in 1925, providing the first detailed description of the Grave-Talbot track.

Concerning the changing of the name from Mt Lippe to Mt Talbot, all the four members of the party to make the first ascent felt very strongly about it. R. S. M. Sinclair wrote to the *Otago Daily Times* pointing out that "Lippe had done nothing towards finding the pass" and that Talbot the discoverer had given his life in the War. Using their prerogative as the first to climb the peak they eventually got their way. The Geographic Board did not accept the name change initially, but the name Mt Talbot became established by common usage, and the Board ultimately in 1980 approved the change. The beautiful pyramid of Mt Talbot which dominates the head of the Hollyford Valley stands as a fine memorial to the man who loved and explored this area.

Regarding the name Lyttle's Farm, the story behind this name became forgotten in time and the name was changed to Lyttle's Flat, then Monkey Flat. After a vigorous correspondence with the Geographic Board in 1943 David Jennings was able to get the Board to restore the original meaningful name of Lyttle's Farm, recalling the exploits of the pioneer explorers and in particular the name of Albert Lyttle who, like Talbot, was killed in the War.

Left: Swiss alpine guide Kurt Suter who acted as both guide on the Grave-Talbot track and cook at the Homer camp.
(J. H. Christie)

Right: The pyramid of Mt Talbot framed in the walls of the upper Hollyford Valley.
(J. Hall-Jones)

CHAPTER 11

The Milford Road begins

The only tools the road gangs had were picks, shovels, crowbars and wheelbarrows.
Gus McGregor, 1930

Prior to the Milford Road there was a lakeside road from Te Anau Downs Station to the tiny township of Te Anau at the foot of the lake. After a particularly rough trip on the lake in the station wool boat, John Chartres determined to construct a lakeside road as an alternative way of getting the wool bales out.

Cyril Beer recounts how in 1927 he took a Model T Ford up on the deck of the wool boat to be used as a transport back and forth from the homestead while constructing the road. Seventeen bridges were required, including large ones over Henry Creek and the Upukerora River and Beer cut the timber for all of them. Using picks and shovels they constructed the road within a year, their greatest obstacles being swamps. "Even after the completion of the road we always carried a shovel and an axe on the back of the Model T in case of floods and fallen debris."

"We were using the road for a good eighteen months before the Public Works Department decided to upgrade it and continue the road up the Eglinton Valley." Its Resident Engineer in Invercargill, W. G. ("Big Bill") Pearce, came up to inspect the road and John Chartres and Cyril Beer drove him over it in the Model T. "There were just two inches to spare between the car and the trees in some places and at the end of his tour of inspection Pearce commented wryly, 'I'll give you your ticket for driving anyway!'"

When the Public Works began work on the Milford Road in 1929 it "more or less followed the line of the original road", but deviated inland to avoid the swamps.

The Milford Road Begins

The Milford Road eventuated as one of the unemployment schemes set up by the government during the depression years of the late 1920s. Beginning in 1929, 200 men with picks, shovels and wheelbarrows formed a new road to Te Anau Downs Station. A painting by Miss E. Nicholson shows the start of the Milford Road as it looked in the 1930s. No shops or fancy restaurants along the

Bridge piles of the old lakeside road at Henry Creek. *(J. Hall-Jones)*

roadside in those days! Only the Public Works depot about a kilometre up the road on the right and manuka scrub lining the narrow gravel road right to its very edge.

One of the early workers on the road was Angus ("Gus") McGregor who arrived in Te Anau in August 1930 and was taken by boat to Te Anau Downs where he and his mates were issued with a "palliasse each and were shown some straw with which to make a mattress". They carried their gear and

What the start of the Milford road looked like in the 1930s. A narrow gravel road lined by manuka, with the Public Works depot in the distance. Painting by Miss E. Nicholson, 1930s. (Rod Hall-Jones)

up the Eglinton or Clinton Valleys. The latter was of course the route of the Milford Track. Heaven forbid! Fortunately the reconnaissance survey fell to Harold Smith, an experienced Fiordland surveyor who had worked on Tom Preston's survey, and the practical Smith found a suitable line up the Eglinton Valley to the Divide. "Smithy" as he was known was well liked by the roadmen and Smithy Creek in the Eglinton Valley was named after him. Also MacKay Creek after his chainman, Jack MacKay.

As the road proceeded up the Eglinton Valley the roadmen struck their first real obstacle at the bluffs where the Eglinton River runs close beside the road. At least one vehicle tipped into the river before the bluffs were blasted and stone embankments pushed out into the river.

Tall beech trees had to be cleared in the line through the Eglinton forest to make way for the road. Skilled bushmen using crosscut saws mattresses up to the roadworkers' camp which was at Mistletoe Creek, where the motor inn now stands. "The only tools the road gangs had were picks, shovels and crowbars. While four of the gang did the picking and shovelling into wheelbarrows, the other two wheeled the spoil away to build up the foundations of the road. Extra barrows were provided so that there was no standing round waiting for your barrow to be filled." The workers were paid "14 shillings" a day for six days of the week, but if it was wet there was no pay at all!

For the continuation of the road from Te Anau Downs a decision had to be made whether it should proceed

Gus McGregor who describes working on the Milford road during the 1930s. (H. Anderson)

Roadworkers' camp alongside the road at Mistletoe Creek, Te Anau Downs, 1930. Boat Harbour in background. (Work Civil Construction)

Sawpit of the Mason brothers at Walker Creek, 1999. *(J. Hall-Jones)*

Right: Upturned truck in the Eglinton River at the bluffs. *(FNBP)*

Harold ("Smithy") Smith who surveyed the road up the Eglinton Valley and later from Milford. *(Smith family)*

(no power saws in those days!) felled the trees, winching them aside and then blasting out the stumps. Bridges had to be built and the first timber for bridges was cut by Tom Mason and his brother in sawpits set up alongside the road as it progressed up the valley. An excellent example of the Mason brothers' sawpits can be seen on the right side of the road on the bend before Walker Creek. 7 metres long and 1.4 metres deep it has a log parapet on each side. There are also a number of sawn tree stumps in the vicinity.

Later a sawmill was set up on the terrace on the far side of the east branch of the Eglinton River. Also on this terrace was road engineer Stanley Walker's house. "He was a big, burly, bespectacled man", recalls Mrs Pamela Pottinger (nee Chartres). "He was in charge of constructing the road up the

THE MILFORD ROAD BEGINS

Eglinton Valley and Walker Creek was named after him." The concrete chimney base of Stanley Walker's house can still be seen on the tussock terrace above the road beyond the East Branch of the Eglinton River.

The last sawmill in the valley was just past the 37 mile peg, in the Avenue of the Disappearing Mountain, where a track leads off the road on the right to a clearing. This sawmill was powered by a DT tractor and operated by the Brown brothers, Mervyn, Colin and Sandy (after whom Sandy Brown Road in Te Anau is named). "Mervyn was a big powerful man", recounts Raymond Wilson, "who first began working on the Milford Road in 1930 in the bush clearing gang. Later as headman of the sawmill he became the overseer of bridge building on the road."

Road engineer Stanley Walker who was in charge of constructing the road up the Eglinton Valley in the early 1930s. *(Weekly News)*

One of the largest bridges to be built was over the East Branch of the Eglinton, where the Public Works initially had a log footbridge which was soon swept away. This was replaced by a handsome wooden bridge with high latticed sides, which preceded the present concrete structure.

Probably the first outsider to dwell on the roadside was Molly Dwan who arrived in the early 1930s and built her cottage, "East Lodge", on the bend before the East Branch bridge, below the terrace on the right. She ran a small tearoom at "East Lodge" and Harold Anderson tells how she "planted out a beautiful flower and vegetable garden, complete with paths and pergolas, and a fence to keep out wild pigs and deer". Molly Dwan obviously loved this wild isolated area and she became known as "the maid of the mountains". She later married Stan Shore the medical attendant at Marian and later Homer camps.

As well as Molly Dwan's "East Lodge" tearoom, there was a tea kiosk and small accommodation house at Cascade camp, the next major camp on the road. It was run by Melita Aitchison, the wife of one of the roadmen and was in the little clearing on the right side of the road on the approach to the Cascade bridge. An early photograph shows the Cascade Creek tea kiosk in its heyday and although it has long since disappeared, the daffodils and lupins of the surrounding garden still flower each spring. Melita Peak and the Melita

The Brown brothers, Colin (left), Mervyn (on tractor) and Sandy, with the DT tractor that operated their sawmill near Wesney Creek. *(C. Brown)*

Below: The original wooden bridge at the East Branch of the Eglinton River. *(Work Civil Construction)*

Molly Dwan's tearoom, East Lodge, with pergolas and stone wall outside.
(Weekly News)

Left: Molly Dwan and her dog Roy seated on the stone wall outside "East Lodge", 1932.
(J. Chartres)

Above right: The large road workers' camp at Cascade Creek, 1932.
(FNPB)

Below right: Melita Aitchison's accommodation house and tea kiosk at Cascade Creek, 1930s.
(M. Aitchison)

THE MILFORD ROAD BEGINS

Falls at Lake Gunn are named after the proprietoress of the Cascade Creek tea kiosk.

The Cascade Creek kiosk preceded the Cascade Creek Lodge and probably explains the name Kiosk Creek further down the road at Knobs Flat. "There was neither a roadworkers' camp nor a kiosk at Knobs Flat", road overseer George Burnby informed me. "I established the current road maintenance depot in 1953 and took the first hut up on the back of my van".

"Gus" McGregor recounts how he lived at the large roadworkers' camp at Cascade Creek and afterwards at "Mud camp" at the head of Lake Gunn

Roadworkers' camp alongside the road round Lake Gunn. *(Work Civil Construction)*

Left: Closer look at Melita Aitchison's tea kiosk at Cascade. Note signpost at approach to Cascade bridge. *(FNPB)*

while the road was being constructed round the lake. Mud camp was "so muddy that we carried bags of gravel to put on the floors of the tents so that the clothes in our suitcases didn't turn mouldy". Gus eventually moved to the Te Anau depot where he succeeded the genial Tom Plato (after whom Plato Creek is named) as the Te Anau supervisor.

Left: Overseer Tom Plato at the controls of an early type of horse-drawn grader. (R. Wilson)

Right: Roadworker outside his hut on the Divide. Note narrow gravel road with snow on it. (FNBP)

When the roadworkers moved on from their major camp at Cascade Creek the Tourist Department took over the camp for public accommodation. Later the Automobile Association built the Cascade Lodge there but, after this was burnt down and later flooded out, the site was cleared. Today the only visible evidence of Cascade camp is the large clearing on the left and opposite, the remains of the garden of the tea kiosk.

The roadmen continued the road round Lakes Fergus and Lochie to reach the Divide at the head of the Eglinton Valley in 1934. A camp was established at the Divide in the clearing on the left side of the road, just past the present Divide shelter at the start of the Routeburn Track. An old hut site can be found at the back of the Divide camp clearing with daffodils growing beside it.

From the Divide the big decision had to be made as to "whether to discontinue the work or incur the heavy expenditure required for its completion" through to Milford. In October 1933 engineer John Christie, an experienced climber, was chosen to lead a party of ten men to carry out a reconnaissance survey of the Hollyford and Cleddau Valleys and survey the proposed Homer Tunnel.

CHAPTER 12

Christie surveys the tunnel

With fixed ropes could the Cleddau face below the Homer Saddle be made climbable?
J. H. Christie, 1935

Known as "Little Johnny" by the roadmen, John Christie's small stature belied an inner strength that the men learned to respect. A recognised climber, he was chosen by the Public Works Engineer-in-Chief F. W. Furkett as the best man for the job.

In October 1933 Christie set out from the Divide with his survey team of ten men and found a route down through the steep bluffs to the floor of the Hollyford Valley, where the Marian camp was later established. From their base camp at Camera Flat the surveyors pushed their roadline up the floor of the Hollyford Valley to its head, where a decision had to be made as to whether the Homer or Gertrude Saddles was the better one for the tunnel. From the Hollyford side "the Gertrude Saddle appeared the more promising" thought Christie at the time, but later when surveying the Cleddau side he was to change his mind.

After placing markers on the summit of each saddle the surveyors moved to the Cleddau side. "Only half the party was prepared to tackle the Grave-Talbot track", Christie records, so on 4 December the team split up, the non-climbers taking the long way round via the Milford Track. None of the climbing party, including Christie, had been over the Grave-Talbot Pass before and "some difficulty was experienced on the descent into the Esperance. As a result of getting off the accepted route the party became involved in some steep country and at one place the packs, including the theodolite, had to be lowered separately." Because of this it was 10 pm before they reached the Esperance hut.

After sighting the marker on the Gertrude Saddle they continued down the Gulliver and the right side of the Cleddau (the future roadside) to arrive at Milford, where they struck an impressive thunderstorm.

"On 22 December it rained all day and about 2 am next morning the camp was awakened by a terrific thunderstorm. Words are inadequate to describe such a phenomenon. The vivid flashes of lightning, some to last for several seconds, were followed almost instantaneously by the terrific claps of thunder, reverberating and echoing from the sheer

Christie's survey party leaving The Forks camp in 1933 to cross the Grave-Talbot track and survey the Cleddau Valley. Christie second from right. *(Weekly News)*

rocky mountain sides; any pause filled by the sound of rain pelting down and the tenseness of waiting for the next lightning flash. The tent sites were all five feet above the ordinary river level, but the cook when he flashed his torch saw the floor awash and his boots floating in the current. He managed to grab one but the other sailed out of the door before he could secure it. He spent the rest of the night on the mess table in his galley. Sometimes these storms herald an improvement in the weather but on this occasion the rain continued for three days, with a total fall of nearly four inches."

By now Christie had decided that the right bank of the Cleddau (the opposite bank to the Grave-Talbot track) was the better side for the road. Leaving two men to clear a track down this side he made a fly-camping trip to the head of the Cleddau Valley to look for his marker on the Homer Saddle.

"Next morning threatened to be a serious disappointment. The large boulder used as one of the sighting marks was easily located. Then the theodolite was set up and the skyline searched for the signal left on the observation point near the Homer Saddle. No sign of it! Another search without result. The boulder had been visible from the signal so the signal must be visible from the boulder; that is, if it was still there. To replace it called for at least four days travel and if the weather broke a week could easily be lost. One more search; very carefully along the skyline. Hey, what's that? Yes, there it is, right in a hollow."

With the elusive marker located, Christie was able to estimate the length of a tunnel through the Homer Saddle and where it would emerge. Having now examined the upper Cleddau Valley he concluded that the

Homer Saddle as Christie's party saw it in 1933, with the Homer hut standing bare. Talbot's Ladder leading up from the saddle on right. *(A. C. Gifford)*

CHRISTIE SURVEYS THE TUNNEL

Homer Saddle was better than the Gertrude Saddle for a tunnel.

The reconnaissance survey had been completed in the remarkable time of only seven months (from October 1933 to April 1934). Christie remarked later that "it was really a two year job. But you know how it is, the politicians think about it for a long time then want it done [yesterday]. So we did it."

The Homer Rope

Christie's report was accepted and the way was open for the road to proceed. By 1935 the road surveyors were approaching the Homer Saddle and Christie had to return to make a definitive triangulation survey to fix the line and levels of the tunnel.

This triangulation survey called for seven observation stations, two on the Hollyford Valley side, two on the Homer Saddle and three on Cleddau Valley side. To get to the Cleddau Valley was a full day's journey over the Grave-Talbot Pass and this could only be done in fine weather, which was seldom the case. Christie was running short of time and he hit upon a "possible alternative". He had earlier used Dan McKenzie's fixed ropes on the trickiest parts of the Grave-Talbot route and he wondered if by placing similar ropes on the precipitous face of the Cleddau side of the Homer Saddle he could descend to the valley below. Grave and Talbot had previously examined this cliff face as a route to the Cleddau but dismissed it. Nevertheless Christie decided to give it a go. "To resolve the question I ordered several hundred feet of manilla rope and the blacksmith sharpened assorted lengths of old discarded rock drills" to be used as rope pegs.

On Gertrude Saddle, which Christie initially considered as the better one for a tunnel. Looking down on the Gulliver and Cleddau Valleys, with Milford Sound beyond. *(J. Hall-Jones)*

Below: Esperance hut where Christie and his surveyors arrived late at night after crossing the Grave-Talbot Pass in 1933.

Christie, assisted by "Sid" Mann (seated), on Homer Saddle carrying out his triangulation survey for the Homer Tunnel, 1935. *(J. H. Christie)*

At first a direct descent straight down the cliff to the planned exit of the tunnel was attempted, but abandoned. However it did reveal the prospect of a "better route a little further to the north" end of the saddle. On the second day, using this new route, "we got within a 100 feet of the scree slopes" which gave walking access to the floor of the Cleddau Valley. Then on 16 February 1935 John Christie, John Grindley and Bill McCallum fixed ropes on this last section and proceeded to make the first crossing of the Homer Saddle by way of the precipitous cliffs of the western face.

The direct "Homer rope" route solved Christie's problem in obtaining the three Cleddau trig stations. The final two stations on the 'razorback' Homer Saddle itself presented no great difficult except in one spot. "Here a boulder the size of a house blocked the way. It was found possible to get round this below the overhang on the Cleddau side, but in doing so one could not stand upright. The theodolite box and tripod secured to a rope had to be passed along from hand to hand to circumvent this obstacle."

Later the 'Homer rope' was used for a mail service to the men working at the Milford end of the road and also for the erection of a telephone line over the saddle for communication during the construction of the tunnel. Paymaster Harold Anderson also tells how it was used as a highly unusual route for paying the men working on the Milford side of the road. After climbing up the Hollyford side of the Homer Saddle Anderson handed the pay packs to "Steve Glasson from Milford who stowed them into one enormous pack" and climbed back down the rope again.

Christie's work was done and he moved on to become assistant chief design engineer at head office. But the name Christie Falls at Falls Creek reminds us of the little man who surveyed the tunnel and made the first crossing of Homer Saddle. In 1941 he returned to Milford Sound with G. Rayward to make the third ascent of Mitre Peak. In later years he worked as an archivist in National Archives and it was here that I met my uncle "Jack" (as we knew him in our family). In his quiet methodical way he was a tremendous help to me in researching the history of Fiordland and the Milford area in particular. He died in 1985 at the age of 88.

"Postie" George Jones using the Homer rope to carry mail to Milford. *(J. H. Christie)*

Three of Christie's assistants, Sid Mann (centre), John Grindley (right) who, with Bill McCallum, descended the Homer rope with Christie. Steve Glasson (left) who used the rope to carry mail to Milford. *(J. H. Christie)*

CHAPTER 13

The Road proceeds to the Tunnel

It was a remote and formidable place to bring a new bride to and I always admired the 'make the best of things' spirit which they showed.
D. White, 1947

From the Divide the roadway was carved down through the bluffs of the steep canyon wall to the floor of the Hollyford Valley where Marian camp was established. A photograph of the Kaka Creek cutting illustrates graphically how the work was done by roadmen using the most basic of techniques. Men drilling holes to place explosives, one man holding a sharpened steel rod, turning it slightly between each stroke, while his mate swings the hammer. Then after dynamiting, the rocks were removed with only barrows to wheel the debris away. No bulldozers or graders in those days!

Below, on a flat beside the Hollyford River, Marian camp was laid out. Here were tent-huts for the men, workshops, a cookhouse and a YMCA hut and even a cinema theatre for recreation. A post office was run by the time-keeper, Dan Campbell and a first aid room by Stan Shore who married Molly Dwan. Marian became the gateway to the Hollyford, literally so when a gate was slung across the road to prevent private cars venturing beyond that point during the winter avalanche season. Later a side road was constructed from Marian down the Hollyford Valley to David Gunn's (now Murray Gunn's) camp and the start of the Martins Bay track.

Most of the buildings at Marian camp were sited inside the hairpin bend of the Milford and Lower Hollyford Roads. The butcher's shop and bakehouse were just inside the acute angle of the bend at the Marian corner and today the concrete foundations of these two buildings can be seen bulldozed into the river below. At the very beginning of the hairpin bend are the remains of the concrete-lined pit that was used for servicing the vehicles at the workshop. About 300 metres down the Hollyford Road, at the back of a little clearing on the right, are the impressive remains of the concrete chimneys of the main cookhouse. Also in "Chimney Clearing" is the concrete chimney base of the YMCA hut.

Continuing up the Hollyford gorge the next camp was placed on the last bend just before the Christie Falls. This was the advance headquarters for the construction of the road until Homer camp eventually took over. It was also

Workmen using hammers and hand-held rods to drill holes for dynamiting. Kaka Creek cutting, Marian Hill. *(Weekly News)*

Marian camp cinema theatre, "The Hollyford Talkies". *(Walter L. Smith, courtesy Colin Smith)*

Marian camp in winter. *(Weekly News)*

Remains of the cookhouse chimney in "Chimney Clearing". *J. Hall-Jones*

THE ROAD PROCEEDS TO THE TUNNEL

used for building the concrete bridge to replace Dan McKenzie's wire swingbridge over Falls Creek.

Beyond Falls Creek the road continued past John Christie's old base camp at Camera Flat, past the future Hollyford power scheme (see later) to burst out on the open flat of Lyttle's Farm, where the modern day motorist obtains his first breathtaking view of the splendid pyramid of Mt Talbot. At the beginning of Lyttle's Farm a camp was erected at Monkey Creek for the construction of the two bridges across this creek. During this period an enterprising bus company used to run regular tours as far as Monkey Creek for tourists wishing to see the progress of the road and the magnificent mountains of the upper Hollyford. In the middle of Lyttle's Farm there is a distinctive solitary beech tree, which appears in early photographs, beneath which there is a concrete picnic table where today's motorists can pause and enjoy the splendour of these mountains.

At the top end of Lyttle's Farm, opposite Cirque Creek, was the Cirque Creek camp. Today the huge concrete oven of the camp's bakehouse can be seen beside the road. The camp itself was in the little clearing immediately past the bakehouse on the opposite side of the road. There, the rusting remains of a corrugated iron chimney can be found, also some raspberry canes still growing.

The next camp was at the Cinques where some roadman planted raspberries at what has become

Remains of vehicle servicing pit, Marian corner. *(J. Hall-Jones)*

Marian dynamite safe, Hollyford Camp Museum. *(J. Hall-Jones)*

The only known photograph of the road Headquarters camp, which was just before Falls Creek. *(Weekly News)*

Below: Camera Flat camp, 1934. Note sticks marking the line of the road. *(FNPB)*

MILFORD SOUND

Remains of the baker's oven of Cirque camp bakehouse. *(J. Hall-Jones)*

The only known photograph of Cirque camp, albeit under snow! *(Weekly News)*

Left: Monkey Creek camp at the lower end of "Lyttle's Farm. Monkey Creek (on left) entering the Hollyford River (on right). Pyramid of Mt Talbot in distance. *(Weekly News)*

known as the Raspberry Patch. But the Raspberry Patchy is a notorious place for avalanches ("Pop" Andrew was killed by an avalanche there) and the roadline was later diverted to avoid this dangerous spot. The line of the original road through the Raspberry Patch can still be followed on the left, beginning at the Hollyford River bridge and finishing at the Hollyford Forks bridge.

At the Forks, where the present Alpine Club huts are, there were residential houses for the engineer and overseer of the Homer Tunnel project. Engineer Donald Hulse lived there with his wife and two children until he was tragically killed in an avalanche in 1937.

The Homer camp for the construction of the tunnel was in the "safe area", out of reach of avalanches, about 500 metres short of the tunnel where the road maintenance depot, the "chapel", now stands. Opposite the "chapel" a wooden bridge, which is still in place, led across Homer Creek to the main part of the camp which included the tent-huts for the workers, the all important cookhouse run by ex-guide Kurt Suter and a bath-house for the men to have a clean up after a day's work in the tunnel. Here too was the old McKenzie hut, by then engulfed by the camp. There was also a line of huts and sheds on the "chapel" side of the road.

By crossing the old wooden bridge the original access road to the tunnel can be followed up past a concrete abutment set in the rocks and then in a wide sweep up to the tunnel entrance. This wide bend gave plenty of clearance for the spoil to be tipped straight out of the tunnel to build up the foundations for today's highway. At the head of the access road, to the north of the tunnel entrance, were the main workshops for the construction of the tunnel.

Harold Anderson in his book *Men of the Milford Road* gives a delightful personal account of the men that he got to know as their paymaster delivering their pay packets whenever he could get through, which wasn't always. The

The Forks camp, now the site of the NZ Alpine Club huts. Homer Saddle and Mt Macpherson in background. *(Weekly News)*

Walking down the line of huts in the snow, 1937. Overseer Harry Morgan on right. *(R. Wilson)*

MILFORD SOUND

Overview from above the tunnel showing the tunnel shelter and workshops in the foreground. The wide sweep of the temporary access road and the spoil from the tunnel being used for the foundations of today's highway. In the distance, the long cookhouse building opposite the wooden bridge. *(FNPB)*

Right: An overview of Homer camp showing the long cookhouse building in the foreground and the shelter built out from the tunnel entrance. Cluster of tunnel workshops to right of entrance. *(FNPB)*

Derelict Homer camp, 1949. *(Alexander Turnbull library)*

Below: Same view today showing the old wooden bridge still there. The line of huts replaced by the "chapel", the road maintenance depot. *(J. Hall-Jones)*

winters were particularly harsh with snow, ice and avalanches and the men living in only tent style huts, which would not be acceptable to workers today. The standard hut had a wooden floor and wooden boarding halfway up the wall. The remainder including the roof was just canvas, or if you were lucky it was topped over with corrugated iron.

Engineer Duncan White tells of how "paydays produced the usual rounds of two-up, poker etc. and the camp bookmakers did a good business. Sundays and holidays produced parties and the [subsequent] Mondayitis" and some real soaks had to be temporarily sent down the road, only to be re-employed a month later. Officially alcoholic liquor was not permitted, nevertheless consignments of liquor got through, often addressed to Clark Gable, Mae West and other exotic noms de plume. Later as the road improved a Hindu fruit and vegetable merchant began to make regular trips up the valley and it was noticed that 'somehow' the men 'suddenly' became well stocked with alcohol after his visits.

"There were probably twenty wives at the Homer camp", records White, "and probably six at Marian and these ladies did a good job in making homes and enduring the snow and wet conditions cheerfully. It was a remote and formidable place to bring a new bride to and I always admired the 'make the best of things spirit' which they showed." For a time there was a school at Homer camp for the children of these married couples.

Concrete abutment on old access road to the tunnel. Homer Saddle above, with Talbot's Ladder leading up from the right end. *(J. Hall-Jones)*

Avalanche streaming down the face above the tunnel, 1936. A warning of what was to come later that year! Photographed from Homer camp with the large store shed in centre. *(R. Wilson)*

CHAPTER 14
The Road from Milford

Baked currant loaf proved a good camouflage for rat fouled flour, as long as not too many men knew about it.
H. W. Smith, 1934

In November 1934 engineer Harold Smith ("Smithy") was sent with a party of 25 men to begin work at the Milford end of the road. There being no accommodation at Milford "Smithy" and ten men walked the Milford Track beforehand to put up tents prior to the arrival of the others by sea. There was still no wharf at Milford so the party set about building one, also a wharfshed, a water reservoir and an access road to the hotel. Then "Smithy", following Christie's recommended route, carried out a systematic survey of the road right up to the future tunnel, pegging out the road and the bridge crossings all the way.

The job took until January 1935 to complete and during this time the rats got into their precious flour supply. "But baked currant loaf proved a good camouflage for rat fouled flour, as long as not too many men knew about it",

Road workers' huts on the river bank at Headquarters camp. Mess and bakehouse in foreground. *(H. Gough)*

Workshops alongside the road at Headquarters camp, now the site of the Milford Sound Lodge. Lorry outside the garage. *(H. Gough)*

commented "Smithy" wryly. Harold Welton Smith MBE took over from W. G. ("Big Bill") Pearce in 1945 as the engineer in charge of the Milford road.

Hitherto nothing has been written about the construction of the road from Milford Sound to the tunnel. I was therefore delighted to find that Hector Gough of Invercargill had worked as an engineer on this section of road for almost two years from 1939 to 1940. Hector was able to give me not only a lucid account of the construction of this part of the road but also illustrate it with his own excellent photographs.

"I arrived as an engineer cadet in 1939", he told me, "and finished up as the sole Engineer in Charge before I joined the Navy to serve in the War. Ian McKinnon [later District Commissioner of Works in Auckland] was the engineer in charge at Milford in the early stages and in 1937 he built the concrete lighthouse tower at St Anne's Point. Then Jack Henderson [later District Commissioner of Works in Dunedin] took over. Jim Paisley was the overseer and was known as 'Swoop' by the men because of his habit of 'swooping' on

"Dutchy" Holland the baker at Headquarters camp. Note double row of workers' huts in background. *(H. Gough)*

Above left: Hector Gough, road engineer at Milford, 1939-40. *(H. Gough)*

Left: Mechanical ("10 RB") shovel loading truck with gravel from the gravel pit near Headquarters camp. *(H. Gough)*

Photograph of the original Tutoko suspension bridge in 1939. This historic bridge is preserved alongside the present one. *(H. Gough)*

Remains of suspension cable of the footbridge across the Cleddau River to bypass the Cleddau bluffs. *(J. Hall-Jones)*

Remains of one of the two huge stone chimneys of the YMCA hall at camp 2, on the island opposite the Cleddau bluffs. *(J. Hall-Jones)*

them while they were having an illegal smoko. 'Dutchy' Holland was the baker and an excellent one too."

Charlie Long, the hotel manager, had decreed that there be no association between the hotel and the workforce, so the headquarters camp (No.1 camp) was established about a kilometre up the road on the site of the present Milford Sound Lodge. The workshops were on the roadside and behind these, on the flat beside the Cleddau River, were the men's huts, the mess and the bakehouse. All the gravel for the road was taken from a gravel pit in the bed of the river near the camp and lifted onto trucks with a mechanical "10 RB shovel" to be carted to the roadhead. "The *Ranui* [until recently an oyster boat at Bluff] used to call regularly at Milford with supplies. But any heavy equipment was landed on the beach at Deepwater Basin in a bay near the present

The Cleddau bluffs at the first view of Mitre Peak, where a temporary footbridge was suspended across the river to camp 2 behind the stoney beach on the left. (J. Hall-Jones)

on the river bank immediately below the island. An identical piece of cable from the footbridge lies on the river bank on the opposite side, below the road.

Suspension bridges with tall towers at each end were slung across the Donne and Gulliver Rivers and the road continued up the valley to about 400 metres short of the Chasm (at the present Chasm road sign) where the next camp, camp 3, was established. Camp 3 was the largest of all the road camps with huts on both sides of the road and a double row of huts on the flat beside the river. "Bath-houses were built on the bank of the river and a bucket with perforations in the bottom served as a shower." Today the remains of hut sites and chimneys of camp 3 can be found on the flat between the road and the river.

fisherman's wharf and brought across the river to the camp by tractor."

The road progressed steadily up the Cleddau Valley to the Tutoko River where a suspension bridge (which is now preserved as an historic monument alongside the current one) was slung across the river. After the Tutoko River came the Cleddau bluffs which had been such an obstacle to the earlier parties and the reason why the Grave-Talbot track had been cut on the opposite side of the river. While the roadmakers were blasting the road round the bluffs a footbridge was suspended across the Cleddau and a camp, camp 2, established on the island opposite the bluffs. The men were then able to bypass the bluffs and work on the road beyond, by following up the Grave-Talbot packtrack and crossing the packhorse swingbridge. Today the impressive remains of the two huge stone chimneys of the camp 2 YMCA hall can be found in the bush on the island. Also a piece of suspension cable of the footbridge, in the grassy clearing

Camp 3, the largest camp on the Milford side of the road, was sited on the flat between the road and the Cleddau River, 400 metres before the Chasm. Note bath-house on river bank in foreground. (H. Gough)

The next camp, camp 4, was at the Cleddau 4 crossing and was used for the construction of this bridge. At first a temporary wooden bridge was placed across the river immediately upstream. Then making use of a huge boulder in the river bed as the base for a foundation, concrete was poured into boxing on top of the boulder. "I argued strongly for the bridge sides to be really low" Hector told me. Fortunately he got his way and today's motorist has an uninterrupted view of the scenery from this and other bridges in the valley.

"We caught a large kakapo while working on the bridge", he recounted, showing me a photograph of someone holding it gingerly with thick leather gloves.

Between camp 4 and camp 5 (at the Cleddau 3 bridge) there was an enormous boulder which had to be "hand drilled with the basic tools that we

Constructing the original Donne bridge. *(A. Murtagh)*

Below: The completed Donne suspension bridge with the original Gulliver bridge beyond, 1939. *(H. Gough)*

Camp 4 at the Cleddau 4 bridge. Note temporary wooden bridge upstream and concrete being poured down chute into boxing on boulder for permanent bridge. *(H. Gough)*

Cleddau 4 bridge today showing concrete foundation sitting on boulder. Also low sides. *(J. Hall-Jones)*

Below: Camp 5 at Cleddau 3 bridge, the last camp before the tunnel. Stone foundations for the bridge in riverbed in foreground. *(H. Gough)*

Below: Huge boulder obstructing the road between camps 4 and 5 which was removed piecemeal. Men working with picks, shovels and wheelbarrows. *(H. Gough)*

Constructing Creek 127 bridge at lower camp 5. Mt Moir on skyline. *(H. Gough)*

Removing tunnel debris by shovel and wheelbarrow after it was pierced in 1940. Tunnel exit hole above the workman. *(H. Gough)*

had, then blasted away and removed piecemeal with wheelbarrows." At Creek 127, half a kilometre short of camp 5, a line of huts was erected alongside the road for the construction of this bridge, as illustrated in Hector's photograph.

"Camp 5 for the construction of the Cleddau 3 bridge was the last camp that we had, because of the avalanche risk. This was the base camp for men working on the tunnel, which made it a long steep climb to go to work!" Much later, when contractors were widening the road, higher camps were put in for work during the safe summer season.

By 1940 the tunnel had been pierced by the tunnellers working from the Homer end and the problem was how to remove the rock debris from the Milford end. A huge bulldozer was brought round in parts on the *Ranui*, then sledged behind a caterpillar tractor up to the roadhead where it was assembled at the foot of the incline to the tunnel.

Closer look at pierced tunnel, 1940. *(H. Gough)*

Caterpillar tractor sledging engine for giant bulldozer up the road. Note temporary wooden bridge. *(H. Gough)*

Tracks for the bulldozer being lifted by mechanical shovel. *(H. Gough)*

Fuel for the bulldozer being brought up by packhorses. *(H. Gough)*

The giant bulldozer assembled and about to take off directly up the steep hillside. Photograph looking down the Cleddau Valley. *(H. Gough)*

Bulldozer with hauling line leading into the tunnel to clear the debris from the Milford end. *(H. Gough)*

Bulldozer framed in the tunnel entrance. Hauling line leading inside and water cascading on right. *(H. Gough)*

Bulldozer forming the road after clearing the tunnel. *(H. Gough)*

Then the bulldozer took off cross-country up the steep hillside to the tunnel entrance. "It was a remarkable, steep climb", commented Hector. Two hauling cables were fed into the tunnel and the bulldozer worked away dragging out the rock debris allowing the tunnel to drain downhill. This done, it proceeded to bulldoze out the steep hairpin roadway as we know it today. "It was a great effort", recounted Hector, showing me his photographs that illustrate the whole sequence. "The tunnel portal had to be deviated a little to one side to avoid a stream of water in a crevice", which explains the slight kink in the tunnel at the Milford end. Because of the threat of invasion during wartime, a human "cattle stop" was sunk at the Milford end of the tunnel and the portal closed off with an iron grille.

While working at Milford, Hector was in the party which landed at the St Anne's Point lighthouse and carried the gas cylinders up on wooden stretchers to service the light. At the end of 1940 he left Milford to join the Navy as a lieutenant in the engineers. With his special knowledge of diesel motors gained at Milford, he was seconded to the British Admiralty to assist in the production of diesel engines for the landing craft for the Normandy invasion. Later his firm, Gough Bros, built the fleet of Fiordland Travel Ltd cruise boats for use on the lakes and sounds.

Right: Portal being constructed at the tunnel entrance. *(H. Gough)*

Left: Human 'cattle' stop sunk at tunnel entrance as a wartime measure. *(H. Gough)*

CHAPTER 15

The Homer Tunnel

The centre of Homer's Pass is a true razorback and could readily be pierced by a short tunnel of 100 feet or so at a total cost of 2,100 pounds.
W. H. Homer, 1889

A tunnel beneath the Homer Saddle was proposed as early as 1889 by the discoverer of the saddle, William Henry Homer. In January the gold prospector William Homer and his mate George Barber explored the upper Hollyford Valley and camped beside the Hollyford River on a "fine flat" (probably Lyttle's Farm) where Homer prophesied that some day a road, or possibly even a railway, would come via the Eglinton and Hollyford Valleys.

On 27 January 1889 they reached the head of the Hollyford Valley and ascended a saddle which led to the west and which Homer had "not the slightest doubt was a good pass to Milford". Calling the saddle "Homer's Pass" he concluded that his discovery was of "immense importance" as the "whole line of country" presented "no engineering difficulties" for a road. "The centre of the saddle", he noted, was a "true razorback" and could "readily be pierced by a short tunnel of 100 feet or so". (It was later estimated by R. W. Holmes to be nearer 1,000 feet.) "I do not anticipate much difficulty on the Milford side, as the valley (Cleddau) can be seen with the bush on each side in the distance. All the hard work of exploration is over", he concluded, "we have headed the Hollyford River and it is this saddle or none".

District Surveyor E. H. Wilmot was the obvious person to check on Homer's "good pass to Milford". In

Left: Holmes' expedition on Gertrude Saddle (summit top centre) in 1890. From left: R. W. Holmes, surveyor, E. H. Wilmot, Gertrude Holmes (after whom the saddle was named). *(Holmes' collection)*

THE HOMER TUNNEL

March 1889 Wilmot set out with a party that included Henry Homer and George Barber and travelling via the Greenstone Valley descended into the Upper Hollyford Valley. On their arrival at Monkey Creek Homer's dog "Monkey distinguished himself by catching a large rabbit", recorded Wilmot in his diary, giving us the true origin of this name for which there has been the previous fanciful explanation of scrambling like a monkey over the bushes. The next day Homer reported "unable to work because of the 'bush itch' and the men got their blankets flyblown. Caught in a thunderstorm. The rain pelted down and the noise of the river and the thunder was deafening."

On reaching the head of the valley they ascended "Homer's Pass" which

Photo by Walter L. Smith of the very beginning of the Homer Tunnel, July 1935. Cutting through the gravel scree to approach the rock face. *(Colin Smith)*

Inside the rock wall and excavating the entrance with picks and shovels, 1936. *(Alexander Turnbull Library)*

Right: Tunnel entrance in early 1936 before the first fatal avalanche. The winch and cement sheds on the right were totally destroyed by the avalanche. Men bringing out truckloads of spoil to be dumped for the foundations of the road. The trolley line curving to the right is to the dynamite store. *(Alexander Turnbull Library)*

Right: Closer view of the generator shed. The transmission lines are from the Hollyford power station. *(R. Wilson)*

Below: Sideview showing tunnel extension which was totally flattened by an avalanche in 1945. Beyond are the generator shed (in front) and other tunnel workshops. The trolley line leading off to the right is to the dynamite store. *(Alexander Turnbull Library)*

Below right: Crushed remains of the tunnel extension after the avalanche of 1945. *(J. Hall-Jones)*

THE HOMER TUNNEL

Wilmot dismissed as "quite useless for the purpose of a route to Milford. The western side is an amphitheatre of rock", Wilmot observed.

In spite of Wilmot's adverse report Homer persisted to advocate for a tunnel. Some extracts from his letters to the *Lake Wakatip Mail* are worth quoting now that the tunnel has become a fact. "No timber wanted, no climbing over ice and snow; no repairs and open all year round. The size of the tunnel 7 ft 6 in high by 6 ft wide, at say one pound 15 shillings a foot to a total of two thousand one hundred pounds [$4,200]. This should open a good horse track all through. A party can be found to accept the work at the figures tomorrow – and glad of the chance." The terms were good but nothing was done.

Homer's letters were embarrassing and in 1890 the Government sent R. W. Holmes, District Engineer for Wellington, to report. Holmes examined both the Homer and Gertrude Saddles (the latter he named after his wife) and reported that the "southern saddle known as Homer's is the only one which is at all suitable for road construction purposes. The construction of a tunnel in connection with a road seems rather stupendous, but it is the only means by

Harry Ryder driving the first truck through the tunnel in 1940. Exiting from the Milford end. *(A. Ryder)*

which a road from Lake Wakatipu to Milford Sound is rendered at all practicable." In a surprising under-estimate for the future Engineer-in-Chief of Public Works he reported that a tunnel eight feet high by six feet wide and 1,000 feet long could be driven through the Homer Saddle for two thousand pounds. It was perhaps fortunate for Holmes' reputation the tunnel was not proceeded with until 1935 when the final total cost was to come to over five hundred thousand pounds [one million dollars].

It took nearly half a century before the decision was finally made to proceed with "Homer's Tunnel". On 4 July 1935 Martin ("Digger") Scully and a party of seven men trundled their heavy wooden wheelbarrows up the valley and camped in the old McKenzie hut. Then armed with only picks and shovels they began cutting their way through 100 metres of loose scree to approach the solid rock wall, shoring up the scree sides with timber on the way. It was slow, tedious work under wet, cold conditions with the ever-present threat of an avalanche from above. But by early 1936 they reached the cliff face and went underground.

The two engineers in charge of the tunnelling, Duncan White (in centre) from Homer side and J. F. ("Jack") Henderson from the Milford side, inspecting the pierced tunnel in 1940. *(H. Gough)*

Hollyford powerhouse which was constructed in 1936 on the riverbank below the 59 mile peg. Note water intake pipe leading down hillside. Transmission lines leading out. *(J. H. Christie, August 1936)*

Hollyford hydro-electric power station August 1936. The generator (in front) and water turbine (at rear) were imported from Great Britain for a total sum of 1,554 pounds ($3,108). *(J. H. Christie)*

Concrete foundations for the power plant, 1999. Generator mounting in centre. Pipeline leading in on left. *(J. Hall-Jones)*

Water intake for the power station 300 metres upriver, 1999. *(J. Hall-Jones)*

Initially the tunnel was excavated "24 feet wide by 17 feet high" with an arched roof and a steep 1 in 10 gradient towards Milford. Then they struck an unexpected problem. Water was pouring through the roof and this had to be pumped out as fast as it came in, otherwise the downward-trending tunnel would fill up. So the dimensions were reduced considerably to "14 feet by 9 feet", with the idea of punching a smaller tunnel through more quickly and getting the water to drain out the far end. The enlarging could come later.

Drills, operated by compressed air, were used to bore the holes in the rock for the gelignite. Then after the drill holes were loaded with explosive the charges were fired electrically from a remote control panel in the drill sharpening shed. The shed and the other tunnel workshops had been deliberately sited well away and at right angles to the entrance so as to avoid the blasts of explosions. Harold Anderson tells the delightful story of how the Governor General Lord Galway was invited to fire a round of these shots. After having the procedure explained painstakingly to him by the overseer, Jack Dawson, His Excellency went to fire the charges, but nothing happened! Not allowing for the delay of the blast the Governor turned quickly for an explanation, only to be caught on the hop, literally, hopping from one foot to another as the succession of blasts went off.

A light railway was built into

THE HOMER TUNNEL

the tunnel and after the dynamiting, the shattered rock was scraped up into buckets and loaded into dump trucks that were pulled uphill to the entrance by an electric winch. A diesel locomotive then took the trucks to be tipped for the foundations of the approach to the tunnel. "A small railway line was built from the entrance of the tunnel to the hillock beyond the workshops", George Burnby informed me, "and at the end of each day the explosives were trucked out of the tunnel to the dynamite store which was safely tucked away among the boulders of the hillock".

The electricity for the tunnelling was provided by the Hollyford hydroelectric power station which was constructed in 1936 about 6 kilometres down the valley from the tunnel. But the 6 kilometre transmission line crossed two notorious avalanche paths en route to the tunnel and was also vulnerable to the fierce lightning storms of the valley. Almost inevitably there were power failures, so a 50 kW diesel generator was installed at the tunnel as a back up. Nevertheless the 250 kW hydro-electric plant served its purpose until 1942 when it was decommissioned and removed to Roxburgh. The foundations of the historic Hollyford power station can be seen by descending the steep trench for the water pipeline on the right of the road at the 59 mile peg. The water intake for the scheme can be found by following down the track at the tiny carpark on the right about 300 metres up the road from the power station.

During the construction of the tunnel there were three fatalities due to avalanches (see later). Then in February 1940 the Milford end of the tunnel was pierced by the tunnellers working from the Homer side. Duncan White, the engineer in charge of tunnelling at Homer from 1937 to 1940, spent his final Army leave walking up the road from Milford to inspect the hole from that side. "It appears to be very much on target", he wrote in his excellent account *The Homer Tunnel*, "and I was relieved to hear afterwards that the line hit the peg". Duncan White departed to the War where he served as a Major, was wounded at the battle of Cassino and was awarded the DSO.

A considerable amount of rock debris had to be removed by the bulldozer working at the Milford end before O. H. Pierce of Downer & Co. on 11 March 1940 led the first party through the tunnel from the Homer side. Downer & Co. carried on drilling holes in preparation for enlarging the tunnel to its full size, but in 1942 all work ceased because of the War and was not recommenced until 1951.

In 1947 the unfinished tunnel was opened to Milford Track walkers wanting to do the round trip and the author can remember the eerie experience of stumbling through the tunnel without a torch in pitch darkness aiming for a tiny pinpoint of light above and away in the distance. I now know what a rabbit feels like when it comes out of a long burrow!

Work on enlarging the tunnel began again in 1951 when Downer & Co.

Bird's eye view of an avalanche across the Milford highway near Homer. *(FNPB)*

were awarded the contract to complete the job. "Arnold Downer spent much time on the job", writes Duncan White, "and recruited experienced miners from Waihi, where they were used to rock work and explosives".

By 1953 Downer had completed the enlarging and in 1954 the tunnel was opened officially to traffic.

Avalanche Fatalities

The fatal avalanches of 1936 and 1937 were both of the swift, silent "dry snow" type where the tremendous force of the wind is the killer more than the actual mass of the snow. In both cases there had been a heavy fall of dry snow on the permanent snowfields high above the tunnel. Then without any warning the layer of fresh snow slid silently off the top of the snowfield at high speed creating a catastrophic blast of wind.

On 6 July 1936 Leigh Overton was in the crib house at the entrance to the tunnel when without any warning at all the wind blast of a "dry snow" avalanche hit the hut smashing it to smithereens, also the winch house and the cement shed. It took over an hour before the men found Overton's badly mutilated body pinned under the remains of the crib house. Stan Shore, the

Tunnel entrance after the first fatal avalanche, 1936. Smashed winch house and concrete sheds on right. Overturned truck at tunnel entrance. Smashed crib house in foreground. *(R. Wilson)*

Above left: Crib house at the tunnel entrance where carpenter Leigh Overton was working when the avalanche struck smashing it to smithereens. Photographed the day beforehand, 5 July 1936. *(R. Wilson)*

Far left: Donald Hulse, engineer in charge, who was killed in the fatal avalanche of 1937. Photographed with his family at their hut at The Forks camp. *(Weekly News)*

Carpenter Leigh Overton who was killed in the fatal avalanche on 6 July 1936. *(Weekly News)*

first aid man, attended to a number of casualties and two of the more seriously injured were placed in the canteen car, converted into an ambulance, which set off down the road to Invercargill behind a tractor with a snow plough.

On 4 May 1937 Joseph ("Joe") Lloyd was in the office at the tunnel entrance discussing plans with Donald Hulse, the engineer in charge and Thomas ("Tom") Smith the tunnel overseer. "Without any warning", Lloyd recounts, "we felt a swish of air and turned to look at each other. Before we could say anything the building was swept away and I can remember nothing more until I regained consciousness in my hut." Both Hulse and Smith were killed and Lloyd considered himself extremely lucky to have been standing between them "and so was [cushioned] from the greatest force of the blow".

Above: Snowplough towing the Homer camp ambulance with three injured men down the road, 1937. *(Weekly News)*

Above left: On lookout duty for a second avalanche while workmen clear the tunnel after the fatal 1937 avalanche. Second from left, alpine guide Alistair Duthie who skied down to headquarters camp at Falls Creek with the news of the tragedy. *(R. Wilson)*

Left: Digging out the tunnel after the 1937 fatal avalanche. Truckload of snow. *(FNPB)*

Far left: Meeting up with the Invercargill ambulance near Cascade Creek, 1937. *(E. H. Buckley)*

built across to the workshops and a long shelter extension straight out from the tunnel. Although the latter was made of heavily reinforced concrete it was crushed completely flat by an avalanche in 1945.

There was yet another avalanche fatality when on 23 September 1983 overseer Robert ("Pop") Andrew was crushed beneath a bulldozer which flipped over in an avalanche at the Raspberry Patch. A memorial plaque to "Pop" Andrew has been mounted at the viewpoint, "Pop's View", on the steep descent from the Divide. Also plaques to Leigh Overton, Donald Hulse and "Tom" Smith at the tunnel entrance.

Recently a technique has been developed to actively "bomb" the threatening snow hanging in the snowfields above the road. Using a helicopter to set off the charges, the accumulated snow is brought down at a convenient safe time, reducing the risk of a rogue avalanche.

Snowplough clearing the road at Homer for the engineers, W. G. Pearce and J. H. Christie (immediately behind the tractor) to assess the damage. *(E. H. Buckley)*

Once again it was the tremendous force of the wind of a "dry snow" avalanche that did the damage. John Milne was sitting in the cab of the diesel locomotive and although the engine "weighed nearly six tons it was lifted bodily in the air and turned over at least four times before coming to rest down the bank". He attributed his lucky escape to retaining a tight grip on the controls while the engine was turned over and over.

Hulse and Smith were both married men and key men at the tunnel. The tragedy shocked the whole of New Zealand and all work was stopped at the Homer Tunnel. The men were shifted away to work down the Lower Hollyford Road for a period. After the double tragedies a concrete covered walkway was

Discussing whether to continue tunnelling or not after the fatal 1937 avalanche. From left: tunnel overseer Harry Morgan, engineers J. H. Christie and W. G. ("Big Bill") Pearce. *(E. H. Buckley)*

Epilogue

Tourists will come in large numbers to see one of the wonders of New Zealand.
Robert Paulin, 1889

In these enlightened days of environmental awareness it seems unbelievable that back in 1924 there was a serious attempt to harness the Bowen Falls for a hydro-electric power scheme. The majestic "foaming pillar of water" was to be encased in an iron pipe and diverted down to a power plant for the production of nitrogenous manures! To service the factory a permanent workforce of 100 men would need to be housed at the head of the sound. The proponent of the scheme, Wellington businessman Leigh Hunt, visited the area with a team of experts and afterwards approached the Minister of Works, J. G. Coates, for a permit to proceed. Astonishingly, and with complete disregard for the Water Rights and National Parks Acts, the minister issued a provisional licence. But when the news was leaked there was such an outcry from the public and opposing politicians that Coates was forced to withdraw the licence. The famous falls were saved.

Cruise Ships Return

It took almost two decades before cruise boats got over the sinking of the *Waikare* and returned to the sounds. Then in 1928 D. McKay Ltd of Invercargill in a joint venture with the Tourist Department put on a cruise in the wooden steamer *Kotare*. The *Kotare* proceeded directly from Bluff to Milford Sound with "over 30" passengers and spent several days there. Plucking up courage she returned via the sounds including the *Waikare's* resting place, Dusky Sound.

The trip was a great success and McKay decided to purchase the government steamer *Hinemoa* for the cruise. Described as "the most graceful steamer afloat" the *Hinemoa* had been used to service the lighthouses and had conveyed Governors as well as prisoners to Milford Sound. Eight day cruises of the sounds were offered at a total cost of "16 guineas, with 2 guineas extra for a stateroom" in the *Hinemoa*. They must have been idyllic days with frequent shore excursions and bountiful returns from fishing expeditions. But the depression brought an end to such cruises and in 1932 the *Hinemoa* was laid up.

Businessman Leigh Hunt (right) and engineer Hugh Vickerman (left) who, in 1924, almost got their way to divert the Bowen Falls for a hydro-electric power scheme. *(A. Leigh Hunt)*

Cruise ship *Monowai* in Milford Sound, 1933. Mt Pembroke beyond. *(J. Churchouse)*

Paradoxically the depression brought more, larger cruise ships to the sound, with companies seeking employment for their out-of-work liners. Among these was the Union Steam Ship Co's ss *Monowai,* which first visited the sound in 1933. Later as HMNZS *Monowai* she took part in the D-Day landings in Normandy, and then returned to the West Coast sounds to update the *Acheron* survey of 1851.

After the War few vessels could be spared for cruising. Appropriately their return to the sounds was heralded by the Royal Yacht *Gothic* which entered Milford Sound on 31 January 1954 with Queen Elizabeth and the Duke of Edinburgh aboard. In 1978 Her Majesty's namesake the *Queen Elizabeth II* visited the sound. Thirty-six busloads of tourists and hundreds more in private cars drove through to Milford to see the world's largest cruise ship in a setting of some of the world's finest scenery. Other liners followed and in recent years the sound has been visited by a dozen or more cruises annually.

Within the sound itself there is now a flotilla of large launches berthed in Freshwater Basin for cruises around the sound. Some stop at the underwater observatory at Harrison Cove to view the famous black coral and other marvels of the deep, and some pick up the 11,000 or so trampers who now walk the Milford Track each year.

Humpback whale leaping out of the sea off Dale Point. *(M Darroch)*

EPILOGUE

Also at Freshwater Basin there is now a spacious visitor centre where Donald Sutherland once had his slab hut with its thatched roof. Here buses disembark their passengers to be re-embarked on one of the cruise boats waiting at the wharves. But let us not forget that it was Donald Sutherland who started it all off when he used to pick up the Milford Track walkers in his little launch *Lizzie* and offer cruises on the sound on demand. Then came the Tourist Department and later the Tourist Hotel Corporation with their launches. The latter held a total monopoly on Milford Sound cruises until 1970 when Les Hutchins, the founder of Fiordland Travel Ltd, quietly but determinedly inserted his launch the *Friendship* and the stranglehold was broken. Today the little launch *Friendship* berths proudly beside her big brother cruisers at Freshwater Basin.

Over at Deepwater Basin are the fishermen's wharves where the fishermen's fleet is based. Here too kayakers can launch their craft to explore the sound in solitude at sea level. Close by is the Milford Sound airstrip where tourists can charter a flight by plane or helicopter to fly over the scenic wonderland that surrounds the sound.

The hard-won Milford Road is now a completely sealed highway with World Heritage status and thanks to the technique of avalanche bombing is open almost every day of the year. Fleets of buses and countless cars traverse the highway loaded with tourists eager to take up the many options that are offered, or just quietly marvel at the magnificence of the whole scene.

How true were the words or Robert Paulin when he prophesied away back in 1889 that: "Tourists will come to far-famed Milford Sound in large numbers to see one of the wonders of New Zealand."

Giant cruise liner *Europa* dwarfed by the Lion, 1994. *(J. Hall-Jones)*

The *Friendship* berthed in Freshwater Basin. *(J. Hall-Jones)*

APPENDIX A

Sutherland's visitors book

Courtesy Mrs T. Rose and the Hocken Library

This is a summarised list of some of the historical entries in Sutherland's visitor's book. Many of these are enlarged upon in the text of the book (see index). The notes in squared brackets are my own.

1882	6 Feb.	Samuel H. Moreton, artist, Invercargill [The first entry]
	26 Feb.	Alfred Burton, photographer, Dunedin
1883	17 Feb.	Wm Hart, photographer, Invercargill
		Samuel H. Moreton [Sutherland took Moreton and Hart to see his falls on this occasion]
1884	6 Feb.	Dr Hector [Sir James Hector]
		William Jervois [Governor Sir William Jervois]
1887	14 Feb.	ss *Hinemoa*. Governor [Sir William] and Lady Jervois aboard.
1888	27 Sept.	C. W. Adams, chief surveyor of Otago in charge of the expedition. The object of the expedition is to measure the height of Sutherland's Falls, to make a reconnaissance survey of the watershed of the Arthur River and find a track overland to Te Anau.
		Thos. Mackenzie. Will. Pillans. Off to Te Anau [!]
	12 Oct.	Sutherland, Pillans and Thos. Mackenzie returned tonight after spending a week exploring the headwaters of Joe's River for a saddle to Te Anau.
	21 Oct.	Quintin McKinnon. Surveyor from Lake Te Anau. Found good available track which connects with Sutherland's track to Falls. Found Government maps very much out and the Hermit's explorations very much in.
	26 Oct.	The Great Sutherland Waterfall is 1,904 feet high. The survey party and all left for Dunedin.
	15 Dec.	F. A. Joseph, Daily Times reporter en route to Te Anau by overland route.
	22 Dec.	F.A. Joseph. Returned from Te Anau via Clinton Saddle.
1889	23 Jan.	Fred Muir
1890	6 Jan.	J. Don, W. Don, Donald Ross. Overland from Te Anau.
	Jan.	Samuel Moreton via Balloon Pass
	7 Feb.	Samuel Moreton, Mrs S. Moreton. Delighted with my trip as I am the first lady to have crossed from Te Anau to Milford.
	9 Mar.	Mr and Mrs Moreton left for Te Anau.
	29 Mar.	C. W. Adams with daughter [Ella] aged 14[!]
	17 Nov.	William Quill. On Govt survey
	14 Dec.	ss *Hinemoa* with 45 prisoners. To cut the Te Anau road. Hume, Commissioner Police.
1892	27 Aug.	Hinemoa left for Wellington with 40 thieves. A good thing for the Country that they cleared out. Have no wish to see them again.
1893	23 Jan.	Kath and Edward Melland, Te Anau Downs station
	31 Jan.	Rich. Henry, Te Anau. [First trip in Jan. 1889 left unsigned]
1895	2 May	Malcolm Ross, Kenneth Ross, W. J. Hodgkins. Explored the north branch of the Cleddau and made the first ascent of Tutoko. [Actually Madeline, which they mistook for Tutoko]
1898	10 Jan.	John and William Don, W. G. Grave, A.C. Gifford. Returned from one week's exploration of the north branch of the Cleddau. [They found no sign of any volcanic activity of Mt Tutoko, as previously reported.]
1900	29 Mar.	John and Louisa Garvey, Glade House with Cyril, John and Charley eight years old [!]
1905	12 Jan.	Dr J. R. Don, Oamaru. The view from McKinnon's Pass more magnificent than ever. This is my 10th journey over the pass [!]
1908	7 Jan.	Basil de Lambert, W. G. Grave, A. Talbot, A. Grenfell. Just returned from fortnight exploring Cleddau in an attempt to get through to Wakatipu.
	8 Feb.	Bertram is on the greenstone track again at Anita Bay.
	21 Mar.	B. Baughan, Banks Peninsula. [Author of *The Finest Walk in the World*]
1910	7 Jan.	W. G. Grave, Arthur Talbot. Arrived at Milford Sd having crossed direct from Lake Wakatipu via the Hollyford and the Cleddau, the first to succeed in traversing this route.
1911	14 Mar.	J. R. Dennistoun, Peel Forest. Climbed Mitre Peak (First ascent) on 13th.

Cartoon (by David Low) of Sir Thomas Mackenzie in Sutherland's visitors book, 1900, with comments by Donald Sutherland. *(Hocken Library)*

APPENDIX B

Historical guide to the Milford Road

In this summarised guide to the historic sites along the Milford Road the sites are localised firstly to the nearest milepost and then pinpointed more precisely to the closest signpost. For further details refer to the index and the text.

15 ml.	Henry Creek side road on left. **Wharf piles** of old lakeside road at mouth of the creek. Follow side road to creek mouth.
18 ml.	Boat Harbour, Te Anau Downs. **Pelton wheel** of Te Anau Downs station's power plant of 1890s on lakeside in front of old station hut.
30 ml.	Walker Creek bridge. **Sawpit** at southern end of small grassy clearing on right before bridge.
34 ml.	East Branch bridge. Site of **Molly Dwan's tearoom** below terrace before bridge. Concrete chimney base of road engineer Stanley Walker's house on terrace after bridge.
37 ml.	Avenue of Disappearing Mountain. **Sawmill clearing** with logs and relics at end of vehicle track on right just past milepost.
47 ml.	Cascade Creek bridge. Site of **Cascade Creek camp** and later **lodge**. Site now cleared but lupins and daffodils planted by the roadworkers still flower there.
50 ml.	Side road on left to head of Lake Gunn. Site of **Mud camp**, but nothing remains.
52 ml.	The Divide, **Divide camp** was in the clearing on the left just beyond the Divide shelter. There is a hut site, with daffodils alongside, at the back of the clearing.
55 ml.	Hollyford road turnoff. **Marian camp.** Vehicle servicing pit beside the road; concrete foundations of the butcher's shop and bakehouse tipped into the river; Chimneys of cookhouse and YMCA hut at "Chimney clearing" 300 metres down Hollyford road on right; Dynamite store at Murray Gunn's **Hollyford Museum,** further down road. Also other exhibits.
56 ml.	Falls Creek. **Headquarters camp** was at the last bend of the road just before the falls but nothing remains. **Camera Flat camp,** also the students' Blowfly camp, were at Camera Flat just beyond the falls.
59 ml.	**Hollyford hydro-electric power station.** At the 59 milepost on right a track leads steeply down to the concrete foundations of the Hollyford power station. The water intake for the scheme is 300 metres further up the road where there is a tiny carpark and track leading down to the concrete intake.
60 ml.	Lyttle's Farm. **Monkey Creek camp** was at the lower end of Lyttle's Farm, near Monkey Creek bridge.
61 ml.	**Cirque camp bakehouse.** The huge oven of the bakehouse is beside the road on the right. The camp itself was in the little clearing on the left immediately past the oven. Chimney remains and raspberries still growing there.
62 ml.	Road to the Alpine Club huts and site of **The Forks camp.** A few rusting relics of the camp can be found to the south of the huts.

Another photo of the Hollyford hydro-electric power station. Note water intake pipe framed in the window. Also fuller view of the concrete foundations for the generator. *(G. Hodge)*

63 ml.	The chapel (the current road maintenance depot). **Homer camp.** The old wooden bridge opposite the chapel leads across to the site of the main Homer camp where many relics can be found. Note the concrete abutment of the access road leading up to the tunnel. At the **Homer Tunnel** entrance note the collapsed portal to the tunnel and the plaques erected to the three tunnellers killed by avalanches. To the right of the entrance the alpine walk leads past the

Diagram of the roadworkers' camps on the Milford road. (J. Hall-Jones)

Historic packhorse swingbridge high above the Cleddau River. (J. Hall-Jones)

	foundations of the tunnel's workshops.
66 ml.	Cleddau 3 bridge. **Camp 5,** the nearest pre-War camp to the tunnel. Some remains of this camp can be found in the clearing beside Creek 126 bridge immediately beyond the Cleddau bridge.
67 ml.	Cleddau 4 bridge. Site of **Camp 4** but nothing remains. Note base of concrete foundation of bridge placed on huge boulder in the river.
68 ml.	The Chasm. **Camp 3,** the largest of the road camps on the Milford side, was sited on the riverflat between the Cleddau River and the road, 400 metres past the Chasm. Many remains of hut sites and relics can be found on this flat.
69 ml.	Gulliver River bridge. On the right the signposted Grave-Talbot track leads to the site of **the Esperance hut** (now demolished). On the left, immediately opposite, a track leads down to the **historic packhorse swingbridge** across the Cleddau River. Cross the bridge and follow the historic trail down to the island opposite the Cleddau bluffs where two huge chimneys of the **Camp 2** YMCA hall will be found. Immediately below the island is a grassy clearing where a piece of suspension cable of the roadworkers' footbridge across the Cleddau River can be seen. An identical piece of suspension cable can be found on the bank opposite, below the road.
70 ml.	First view of Mitre Peak. **Camp 2** (described above) was on the island on the left, opposite the Cleddau bluffs on the right.
72 ml.	Tutoko River bridge. **Historic Tutoko suspension bridge** preserved alongside.
73 ml.	Milford Sound Lodge. Site of the **Headquarters camp (camp 1).** The concrete foundations of the camp's workshops can be seen within the lodge grounds.
74 ml.	Milford Hotel. **Tombstone** on Donald and Elizabeth Sutherland's grave behind the hotel. **Cemetery Point** at the end of the Bowen Falls walk. Tombstone to trackman William Rathbun (died 1894) and memorial stone to victims of the air disaster in 1989.

Bibliography

Adams, C. W.,	*The Great Sutherland Waterfall,* Tasmania, 1892.
Adams, E.,	*The Milford Track, 1890,* courtesy N. Spicer.
Anderson, H. J.,	*Men of the Milford Road, Craigs,* 1994.
Anderson, W.,	*Milford Trails,* Reed, 1971.
Baughan, B. E.,	*The Finest Walk in the World,* Spectator, London, 1908.
Beattie, J. H.,	*Far-Famed Fiordland,* Dunedin, 1945.
Beck, R. J.,	*New Zealand Jade,* Reed, 1984.
Beer, C.,	*Goldminer and Stockman,* 1994.
Begg, A. C. & N. C.,	*The World of John Boultbee,* Whitcoulls, 1979.
Christie, J. H.,	*Pioneering the Milford Sound Road,* unpublished.
Coutts, P. J.,	*Greenstone, Anita Bay,* J. Polynesian Soc., 1971.
Cowan, J.,	*New Zealand Lakes and Fiords,* Govt Printer, 1906.
Crozier, A.,	*Beyond the Southern Lakes,* Reed, 1950.
Dennistoun, J. R.,	*First Ascent of Mitre Peak,* Otago Witness, 7 Feb. 1912.
Edge, D.,	*Sounds of New Zealand are a Sight to Behold,* Sea Breeze, 1994.
Forrester, J.,	diary, 1888, Otago Settlers Museum.
Hall-Jones, J.,	*Early Fiordland,* Reed, 1968.
Hall-Jones, J.,	*Fiordland Explored,* Reed, 1976.
Hall-Jones, J.,	*Martins Bay,* Craigs, 1987.
Hall-Jones, J.,	*Pioneers of Te Anau,* Craigs, 1993.
Hansard, G.,	*Journal of the Acheron,* 1851, Hocken Library
Hector, J.,	*Geological Expedition West Coast,* Otago Prov. Gazette, 1863, p460.
Holmes, R. W.,	*Milford Sound Road,* PWD, Wellington, 1890.
Jennings, D. R.,	*Track Making in Fiordland,* 1974, courtesy Dr L. Stewart.
Mackenzie, T.,	report, Hansard, 1925.
McGregor, E.,	*Mrs Muggins True Stories,* SDC, Te Anau.
McHutcheson, W.,	*Camp-life in Fiordland,* Govt Printer, 1892.
McKay, A.,	*Recent discoveries Milford Sound,* Trans N. Z. Institute, 1883.
McNab, R.,	*Murihiku,* Whitcombe & Tombs, 1909.
Melland, K.,	article, Manchester Geographical Soc., 1914.
Moir, G. M.,	*Guide Book of the Southern Lakes,* Dunedin, 1925.
Moreton papers,	courtesy A.E. Wildey.
Moreton, S. H.,	*Attempt on Mitre Peak,* Weekly Times, Invercargill, 24 Feb. 1883.
Natusch, S.,	*The Cruise of the Acheron,* Whitcoulls, 1978.
Paulin, R.,	*The Wild West Coast of New Zealand,* London, 1889.
Quill, W.,	diary, Alexander Turnbull Library.
Reed, A. H.,	*The Milford Track,* Reed, 1965.
Richards, G. H.,	New Zealand Pilot, 1856.
Richards, J. H.,	*Milford Sound,* Reed, 1963.
Sutherland, D.,	letter, *Lyttelton Times,* 8 May 1907.
Sutherland, D.,	report, *Wakatip Mail,* 21 January 1881.
Sutherland's	*Visitors Book,* courtesy Mrs T. Rose, Hocken Library.
Thomson, A. P.,	*The Battle for the Bowen Falls,* Wellington, 1988.
White, D. U.,	*The Homer Tunnel,* NZ Engineering, 1947.

Index

Bold figures indicate illustrations

A

Acheron, **8, 10,** 9-11, 18, 140
Ada, Lake, 23, **25, 26,** 37, 75
Adams, C. E. ("Eddy"), 36, **40**
Adams, C. W., 26, 34, 35-37, **36, 37, 40,** 39-42, 50-53, 59, 142
Adams, Ella, 50-52, 142
Aitchison, M., 105, **106, 107**
Anderson, H., 105, 112, 117, 134
Anderson, W., 41, 55, **75,** 75
Andrew, R., ("Pop"), 117, 138
Anglem, W., 16
Anita Bay, **8,** 10, 12, 14, **14,** 15, **15,** 16, **16**
Arthur River, 10, **17, 20,** 26, 27, 70, **71, 72, 72, 73**
avalanches, 77, **77,** 135-138, **135-138**

B

Balloon, Mt, **26, 27, 33, 34**
Balloon Pass, 33, 50, **51**
Baughan, B., 69, 142
Beaglehole, J., 30, 31, **70**
Beattie, H., 15
Beautiful (Mintaro) Lake, 35, **35,** 39
Beech (Quintin) huts, 36, **40,** 41, **41,** 46, 53, 69-70

Beer, C., 102
Bertram, W., 16, 142
Birley, H., 64-66
Birley Pass, 64-67, **65**
Boatshed (Poseidon) hut, **55,** 56, 58, 72, **72**
Bollons, J., 97
Boultbee, J., 7, 11, 15
Bowen Falls, 9, **10,** 17, **18, 22**
Bowen, G., 17
bowenite, 10, 15, 16
Brodrick, T., 80-84, **82, 83**
Brod's Bay, 83
Brown brothers, 105, **105,** 143
Buchanan, J., 17, **17**
Bunger hut, 36, **37,** 38, 41
Burnby, G., 107, 135
Burrows, L., **86,** 87
Burton, A., **24,** 36, 142
Burton brothers, 36

C

Camera Flat, 92, **92,** 109, **115**
Campbell, W., 87
Cascade Creek camp, 105, **106,** 107, **107,** 108, 143
Cemetery Point, 18, 24, 57, 144
Chartres, J., 102
Chance, G. R., 100
Chasm, 94, 123
Christie Falls, 112, 113

Christie, J. H., 7, 108-112, **109, 111,** 120, **138**
Cirque camp, **92,** 115, **116,** 143
City of Milford, 24, **24,** 25, **25**
Cleddau River, 9, 12-14, **17, 18, 20, 123**
Cleddau road camps, 122-129, **122-123, 125, 126,** 144
Cleddau swingbridge, 100, **100,** 123, 144, **144**
Clinton Forks hut, 76, **76,** 77
Clinton hut, 43, **43,** 46, 61, 77
Clinton River, 34, 35, 43, **43,** 72
Coates, J. G., 139
Coutts, W., 57
Cowan, J., 15, 69-70
Crawford, H., 68
Crow, S., 65

D

Dale Point, 12, 13
Dallas, D. B., 59
Darran Pass, 7, 88-89, **89**
Dawson, J., 134
De Lambert, B., 88, 89, 142
De Lambert, J., 68
De Lambert Falls, 89
Deepwater Basin, 9, 10, 122, 141
Dennistoun, J. R., 30, **30,** 31, 142

Divide camp, 108, **108,** 113, 143
dolphins, 18, 31
Don, J. R., 49, **49,** 50, 142
Don, W., 49, 142
Donne River, 88, **89,** 123, **124**
Donne, T. E., 86, 88
Dore, J. B. C., 66-67, **67**
Dore Pass, **67,** 68
Doughboy hut, 41, 53
Downer, A., 135
Duncan, F. M., **39,** 43, 46, 47, 81, **82,** 84
D'Urville, D., 12
Duthie, A., **137**
Dwan, M., 105, **106,** 143

E

East Branch, 105, **105**
East Lodge, 105, **106**
Edgar, J. **91,** 95
Ella, Lake, 51, **52**
Esperance hut, 94, 98, **99, 111,** 144
Esperance Valley, 89
Evans, F, J., 9, **10,** 14, 18

F

Falls Creek, 92, **93**
Forrester, J., 36
Fox, H., 16
Fox Point, **14,** 16
French, M., 54-55

Freshwater Basin, 9, 10, 24, 140-141
Friendship, 141, **141**

G

Galway, Lord, 134
Garvey, C., 61, 142
Garvey, J., 60-61, **60,** 81, 142
Garvey, L., 60-61, **60, 61,** 142
Gertrude, Lake **130**
Gertrude Saddle, **58,** 59, 109, 111, **111,** 113, **130,** 133
Gilmore, H., 56, 57
Glade House, 60-68, **61, 63, 64, 65**
Gordon, S., 75-76, **76**
Gough, H., 7, 121-129, **121**
Graham, P., 96
Grave, Mt, 11, **11,** 92
Grave, W. G., 88-92, **88, 90, 92,** 94-96, **95,** 142
Grave-Talbot Pass, 90, **90,** 95, **95,** 100, 109
Grave-Talbot track, 88-101, 109, 123
Grenfell, A. ("Gulliver"), 88, 142
Grindley, J., 112, **112**
Grono, J., 7, 11, 12, **12,** 14
Gronow's, 11, **11**
Gulliver River, 89, 123, **124**

H

Hall, W. Y. H., 34
Hall-Jones, G., 7, 89
Hamilton, W. J. W., 10, 11
Hansard, G., 9, 10, 11
Hart, Mt, 32, **48,** 59
Hart, W. P., 27, 32, 142
Headquarters camp, Falls Creek, 113, **115,** 143
Headquarters camp, Milford, **120, 121,** 122, 144
Hector, J., 7, 16-18, **17,** 142
Henderson, J. F., 121, **133**
Henry, R., 47, 48, 49, **50,** 80
Hinemoa, 19, 20, 54-55, **54,** 57, 97, 139, 142
Hollyford power station, **134,** 135, 143, **143**
Holmes, G., **130,** 133
Holmes, R. W., 130, **130,** 133
Homer camp, 117-119, **117, 118, 119**
Homer hut, 98, **99,** 101, **110,** 117, 133
Homer rope, 111-112, **112**
Homer Saddle, 59, 89, 109-112, **110,** 119, 130-138
Homer Tunnel, 109-110, 126-129, **126, 127, 128, 129,** 130-138, **131-133, 136, 137**
Homer, W. H., 130-133
Howden hut, 66, **66,** 98, **99, 100**

Hulse, D., 117, 136, **136,** 138
Hume, A., 54, **54,** 142
Hume Road, 54-55, 75
Humeville, 54
Hunt, L., 139, **139**
Hutchins, L., 87, 141
Hutton, D. C., 45

J

Jennings, D. R., **91,** 92-99, **92, 94, 98,** 101
Jennings, H., **90, 93, 98,** 101
Jervois Glacier, 39, **52**
Jervois, W., 20, 39, 142
Joe River, 27, 32, 37
Johns, B., **90, 94,** 95-96, **95, 96,** 101
Joseph, F. A., 49, 142
Juliet, **46, 47**

K

Kaka Creek cutting, 113, **113**
kakapo, 15, 28, 38, **38, 39,** 94, **94,** 124
keas, 59, 93
King, T., 48, 49
Kotare, 139

L

Lake Gunn camps, 107, **107,** 143
Lion, 9, **10,** 18
Lippe, J., **70,** 91, **92**
Lippe, Mt, 101
Lloyd, J., 136
Long, C., 16, 122
Lyttle, A., **88,** 89, 101
Lyttle's Dip, **90,** 91
Lyttle's Farm, 89, 92, 101, 115, **116,** 130

M

MacDonald brothers, **15,** 16

McCallum, W., 112
McGeorge party, 65, **65**
McGregor, A. ("Gus"), 102, 103, **103,** 107
McHutcheson, W., 42-47, 82-84
McKay, A., 33
McKay, D., 139
McKay Falls, 26, **27**
McKay, J., 25-27, **28,** 32
MacKay, J., 103
McKenzie, D., 93, 98, **99,** 100
McKenzie, H., 16, **16**
McKenzie (Homer) hut, **99, 110,** 117, 133
Mackenzie, Lake, 65
Mackenzie, Mt, 32, 39, 58
Mackenzie, T., 36-39, **36, 38,** 64-65, 142, **142**
McKinnon, I., 121
Mackinnon monument, **47, 48**
Mackinnon Pass, 33-39, **33, 34, 38, 47**
Mackinnon Pass shelter hut, 73-74, **74**
Mackinnon, Q., 32-39, **34, 37, 38, 39,** 42-48, **44, 46,** 51-52, 142
Mackinnon's hut, 43-45, **44, 45,** 63
Macpherson, D., 91
Macpherson, Mt, 89, **90,** 91, **117**
McPherson, W., 98, **99**
Madeline, Mt, 29, 98, 142
Malcolm, James, 20, 27
Malcolm, John, 27
Mann, S., **111, 112**
Maori, 9, 10, 15
Maori, **19,** 20, 27
Marakura Hotel, 60, 81, **87**
Marian camp, 113-115, **114, 115,** 143
Mason brothers, 104, **104,** 143
Matilda Hayes, 17, 18

Melland, E., 60, **60,** 142
Melland, K., 42, 47, **47,** 60, 80, 142
Meurant, E., 11, **11**
Mid hut, 61, **62**
Milford Haven, 11-15, **11, 12, 13**
Milford Hotel, 78-79, **79,** 122
Milne, J., 138
Mintaro hut, 46, 61, **62,** 63, 69
Mintaro, Lake, 35, **35,** 39
Mitchell, E., 34, **34,** 35, 37-39, **37, 38**
Mitre Peak, 9, **10, 18,** 29, **29,** 30, **31,** 112
Moir, G., 72, **91,** 92, 93, **94, 95,** 97, **98,** 101
Moir's guidebook, 72, 92, 101
Monowai, 140, **140**
Monkey Creek camp, 115, **116,** 131, 143
Moreton, R., 50, 142
Moreton, S. H., 27, 29, **29,** 34, 50, **50, 51,** 142
Morgan, H., **117, 138**
Muir, F. M., 36, 39, **41,** 49, 142
Murray-Menzies, R., **84,** 85-86, **85**
Murcott, 64
Murcott Burn, 64, 66
Murcott Burn hut, **66**
Murrell, G., **15,** 16
Murrell, J., 31
Murrell, R., 64

O

orange wattled crow, 38
Overton, P. L., 135, **136**

P

packhorses, **61,** 64, 76, 79, **79**
Paisley, J. ("Swoop"), 121

Park J., **91**
Paulin, R., 7, 19-22, 141
Pearce, W. G., 102, 121, **138**
Pembroke Castle, 13, **13**
Pembroke, Mt, 9, 10, **11,** 12, 13, **13**
pianos, 75, **75**
Pillans, W. S., 36-39, **36, 37, 38, 39,** 142
Piopiotahi (native thrush), 15, 38
Plato, T., 107, **108**
pompalona, 45
Pompalona hut, 45, **45,** 46, 69, **69, 70,** 75-76, 77, **77**
Porpoise, 22, 24, 27, 28
Poisedon River, 26, 37
Poisedon (Boatshed) hut, 56, 58, 61
Post Office Rock, **14,** 16
Preston, T. W., 97, **98,** 101, 103
Price, E., 55-57, **55, 56**
Price's gang, **55, 56**
punga (Bunger) boatshed, 36, **37,** 38, 41

Q

Queen Elizabeth 2, 140
Quill, J., 51, 59
Quill Lake, **57,** 58, **58**
Quill, T., 59
Quill, W., 50, 57-59, **57,** 142
Quintin (Beech) huts, 53, **53,** 69-70, **71,** 75

R

Ranui, 122, 126
Rathbun, W., 18, **55,** 57
Reed, A. H., **79**
Reid, Miss, 74
Richards, G. H., 9, 10, **10,** 14
Roaring Burn, 35, 46, **53**
Robb, R., **86,** 87
Roberts, T., **47,** 86, **86**
Ross, D., 56, 61, 63, **63,** 65, 81, **82,** 84-86, 142
Ross, J., 63, 65, 81, **82,** 84-86, **84**
Ryder, H., **133**

S

saddleback, 22, 38
Sandfly Lodge, 71-72, **73**
Sandfly Point, 54
Seddon, R., 55
Shirley, K., 7, 75-76
Shore, S, 105, 113, 135
Sinbad Gully, **29, 31**
Sinclair, R. S. M., 97, 101
Slab (Beech) hut, 36, **40, 41,** 44
Smith, H., 103, **104,** 120-121
Smith, T., **136,** 138
Smith, W. L., 114, 131
Snodgrass, W., 81
St Ann(e)s Point, 12, 14
St Ann(e)s Point lighthouse, 14, **14,** 121, 129
Stella, 20, **20,** 24
Stewart, L., 30
Stewart, R., 89
Stirling Falls, 9, **9,** 10, 17
Stokes, J. L., 7, 12-14, **12**
South Pass, 32, **32,** 33, 34
Suter, K., 100, **101,** 117
Sutherland, D., 20-22, **21,** 23-30, **23, 24, 25,** 28, 32-34, **33,** 37, **37, 96,** 97, **97,** 141
Sutherland, E., 71, 93-94, **94,** 96-97, **97**
Sutherland Falls, 26, 27, **27,** 32, 37, 39-41, 52-53, **53, 57,** 58-59
Sutherland, Mt, 32, 39, 58
Sutherland Sound, 28, **28,** 33, 37
Sutherland's accommodation house, **73, 94, 96,** 97
Sutherland's visitors book, 30, 36, 38, 142

T

takahe (notornis), 10, 84
Takahe, 80, **80**
takawai (bowenite), 10, 15, 16
Talbot, A., 88-91, **88, 90,** 101, 142
Talbot, Mt, (Lippe), 97, 101, **101, 116**
Talbot's Ladder, 89, 95, 98, 100, **110**
Tarawera, 21, 52
Tawera, **63,** 84-87, **84, 85, 86, 87**
Tayor, T., **91,** 92, **92,** 94, **94,** 101
Te Anau Hotel, 81, 85, 86, **86**
Te Anau township, 80-87, 102
Te Anau Downs Boat Harbour, 102, **103**
Te Anau Downs station, 42, 47, 80, **80,** 102, 143
telephone line, 64, **72,** 112
Te Uira, 54, 61, **81, 82, 83**
The Forks, 89, **91,** 117, **117, 137,** 143
Tutoko bridge, **122,** 123, 144
Tutoko, Mt, 11, **11,** 95-96, **95,** 142
Traverse Pass, 97, **98**
trout liberation, 37
Turner, S., 75, 96

W

Waikare, 21, **21,** 139
Walker, S., 104-105, **105**
Wanaka, 22
White, D., 119, **133,** 135
Wilkins, E., 57-58
Williams, E., 31, **95,** 96
Wilmot, E. H., 130-133, **130**
Wilson, L. W. **40,** 41, 45, **45**
Wyinks, W., 36, 37

Text: 10/12 New Century Schoolbook
Paper: 128gsm silk matt art
Book jacket: 128gsm gloss art
Book design: Ellen van Empel
Book bound by F. Cartwright & Son Ltd, Christchurch, New Zealand.
Printed by Craig Printing Co. Ltd, Invercargill, New Zealand.

Survey map of Grave-Talbot track by T. W. Preston, 1924. *(National Archives, Dunedin)*